IMAGES
of America

GOLD MINES
in NORTH CAROLINA

IMAGES
of America

GOLD MINES
in NORTH CAROLINA

John Hairr and Joey Powell

ARCADIA
PUBLISHING

Published by Arcadia Publishing
Charleston, South Carolina

Printed in the United States of America

Library of Congress Catalog Card Number: 2004110106

For all general information contact Arcadia Publishing at:
Telephone 843-853-2070
Fax 843-853-0044
E-mail sales@arcadiapublishing.com
For customer service and orders:
Toll-Free 1-888-313-2665

Visit us on the Internet at www.arcadiapublishing.com

CONTENTS

INTRODUCTION

Gold has been the object of man's desire since the beginnings of civilization. Rare and beautiful, it has been prized by man since his appearance on earth. Artisans living in early cultures such as those in Egypt and Assyria took this prized element and made it into visually appealing works of art.

Throughout history, gold has been used as a medium of exchange, valued by all peoples. The chance of its discovery was a major reason behind the voyages of such expeditionary captains as Christopher Columbus. His land discoveries, claimed for the throne of Spain, led to armies of Spanish conquistadores searching the Americas for gold. Much was found in South America, and large Spanish ships, named galleons, were built to transport the newly found treasures along the Spanish Main, across the Atlantic to the Spanish homeland.

Spain's military rival England also developed a strong interest in searching for gold in the Americas. Claiming North America as a result of the John Cabot voyages, the English, under the command of Sir Walter Raleigh, sent expeditions to search for the elusive, rare metal in their newly claimed lands. Elusive it was; the English never discovered gold in North America, so they later turned their attention to agriculture-based colonies. But the English pursuit of American gold was far from over. Swift ships, led by such daring seadogs as Sir Francis Drake, Sir John Hawkins, and Sir Richard Grenville, attacked the slow-moving, gold-laden Spanish galleons with great success.

Probably unaware of England's lack of success in finding North American gold, the Spaniards launched expeditions there as well. Led by men such as Hernando de Soto and Juan Pardo, at least two of the expeditions are known to have explored the mountains of Western North Carolina. But like their English rivals, they found no gold in what is now the southeastern United States.

It is ironic that these European expeditions found no gold in an area later renowned as one of the richest gold producing sections of the country. There was gold here, and the Indians knew about it. Though their precious metals did not impress the Spaniards, the Cherokee were long reputed to possess a secret source of that which the Europeans craved. According to an oft-told tale, the Indians molded bullets from the yellow metal, which they shot from their flintlocks obtained in trade with the English or French. Their source for this gold was a mine hidden in the coves and ridges of the Great Smokey Mountains, near where Bryson City stands today.

Although used as the main source of money in England's American Colonies, and later the young United States, the gold then in use was not native to the new nation. This changed on a

spring morning in 1799 in North Carolina's Cabarrus County, when 12-year-old Conrad Reed discovered a 17-pound gold nugget while fishing. More gold was discovered, and the Carolina gold rush, North America's first, was on.

Since the discovery on the farm of John Reed (Conrad's father), North Carolina held the distinction of being the nation's leading gold-producing state. This reign lasted 50 years, until gold was discovered at Sutter's Mill in California, setting off the famed California gold rush.

Gold was plentiful in the Old North State, especially in the areas around the Reed Mine and the nearby Uwharrie Mountain region. Many mines opened, and a large amount of gold was extracted. Boom towns such as Rowan County's Gold Hill sprang up to meet the demands of large numbers of would-be gold miners arriving daily to seek their fortunes. Gold Hill held eastern America's largest and deepest gold mine, with several million dollars' worth of this most precious metal extracted.

Two types of gold deposits were found in North Carolina. In underground and open pit mines, gold ores were found in veins, usually embedded in quartz. Once taken from the mines, the ores were crushed using various methods to extract the gold. The other type of prevalent gold extraction was placer mining. Using pans, rockers, and sluices, miners washed the eroded ores of gold-bearing rocks in hopes of finding rich nuggets.

Although many of North Carolina's mines were worked until exhausted, several operated until World War II, when President Franklin D. Roosevelt closed them, claiming he needed the miners to work for the war effort.

Most of these mines are now only a memory, although some, such as the Reed Mine and Gold Hill, have been restored and host large numbers of visitors daily. Others have been virtually forgotten, with many now covered by the advances of civilization, such as the Rudisill Mine and the St. Catherine Mine, whose remains lie buried under the busy city streets of downtown Charlotte.

One

REED GOLD MINE

The nation's first gold rush began in Cabarrus County, North Carolina, predating the famed California gold rush by 50 years. It began on a springtime Sunday morning in 1799 when 12-year-old Conrad Reed, son of John and Sarah Reed, decided to skip church and go fishing in Little Meadow Creek, which ran through his father's farm. While reaching in the water to retrieve a fishing arrow, he spotted an unusually shiny yellow rock. Unable to identify the rock, the Reeds used it as a practical and decorative doorstop. In 1802, John Reed took the 17-pound rock to Fayetteville and showed it to a jeweler, who immediately recognized it as gold. The jeweler offered to buy it from Reed and asked him to name his price. Reed asked for $3.50. About a year later, Reed discovered the real worth of the rock and eventually recovered around $1,000. The Reed property is now part of the Reed Gold Mine State Historic Site.

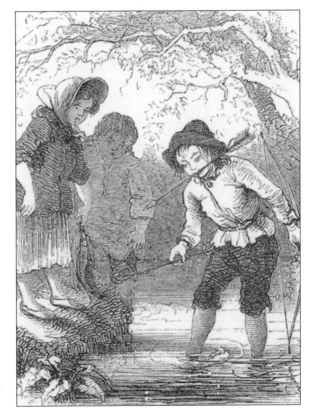

For many years, Spanish explorers searched for gold in the mountains of Western North Carolina.

Hernando de Soto is the most famous Spanish explorer to traipse across the southeastern United States looking for gold and other riches. Although the land was rich in gold deposits, the Spaniards never found what they sought.

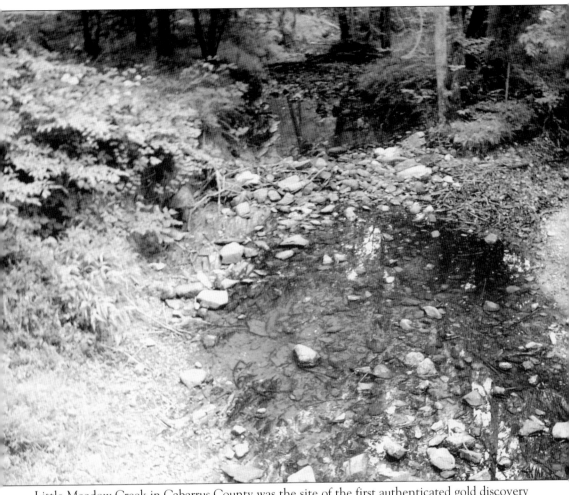

Little Meadow Creek in Cabarrus County was the site of the first authenticated gold discovery in North Carolina, back in 1799.

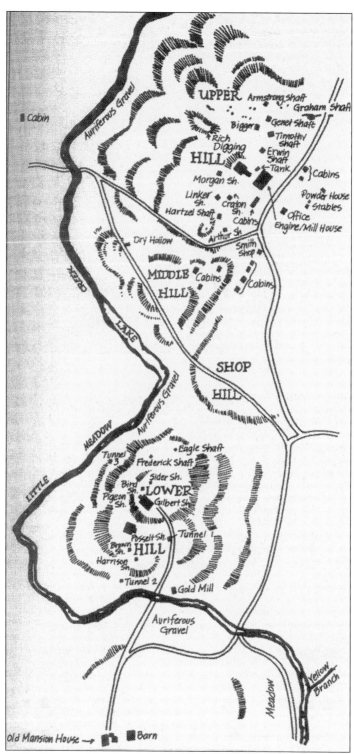

This map shows the layout of the Reed Gold Mine. It is based on an 1854 map of the mine drawn by August Partz. (North Carolina Archives and History.)

This view looks up the Morgan Shaft toward the surface from deep within the earth at the Reed Gold Mine.

The Linker Shaft cuts into the side of Upper Hill and leads underground into the Reed Gold Mine. Today, guides lead tours where miners once worked to extract ore from underneath the hill.

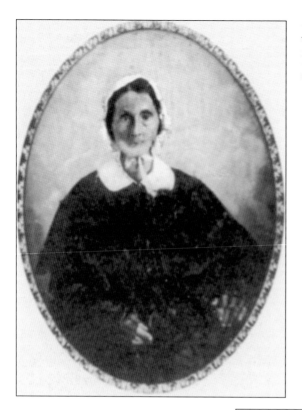

John Reed's youngest daughter, Patsy, was the wife of George Barnhardt. (North Carolina Archives and History.)

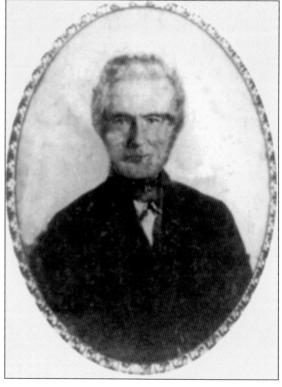

George Barnhardt married the daughter of John Reed and sister of Conrad. George played an instrumental role in the mining activities in the area and eventually took over the operation of the Reed Gold Mine. (North Carolina Archives and History.)

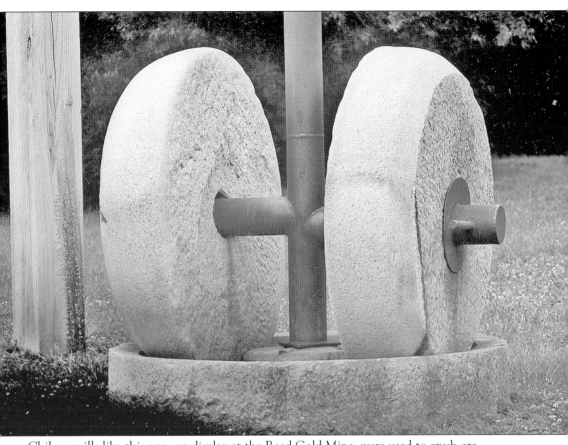

Chilean mills like this one, on display at the Reed Gold Mine, were used to crush ore.

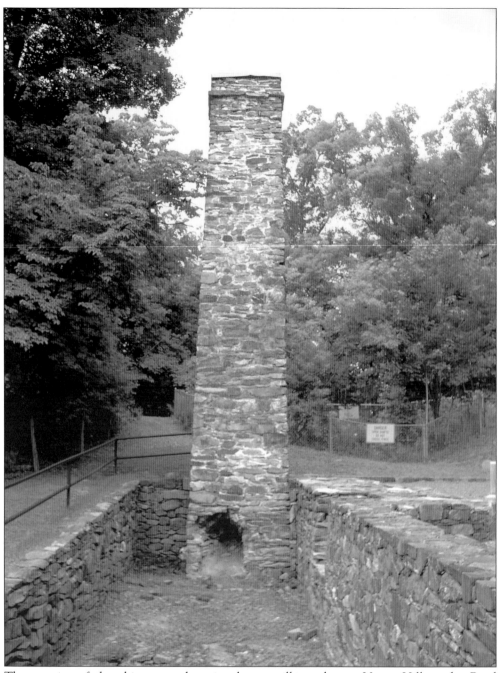

The remains of the chimney and engine house still stand atop Upper Hill at the Reed Gold Mine.

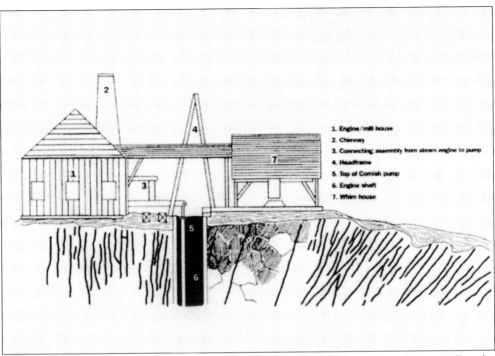

This drawing, made in the 1880s, shows the various structures that stood atop Upper Hill at the Reed Gold Mine. (North Carolina Archives and History.)

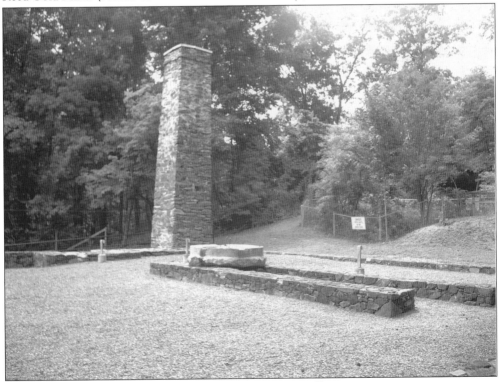

This photo shows the ruins of the structures atop Upper Hill.

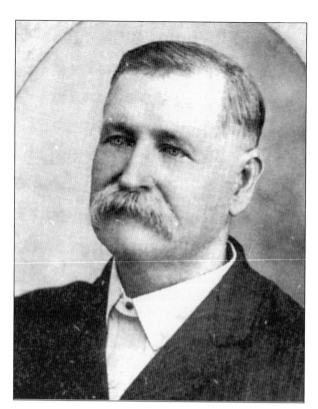

Jacob Shinn found a 22-pound gold nugget at the Reed Gold Mine in April 1896. (North Carolina Archives and History.)

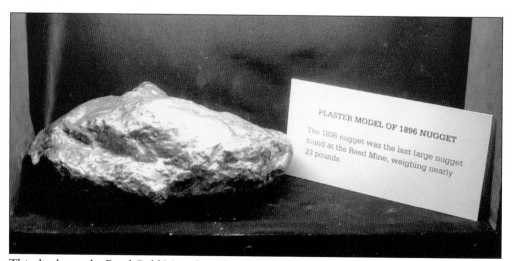

PLASTER MODEL OF 1896 NUGGET

The 1896 nugget was the last large nugget found at the Reed Mine, weighing nearly 23 pounds.

This display at the Reed Gold Mine State Historic Site shows a reproduction of the large nugget found by Shinn in 1896.

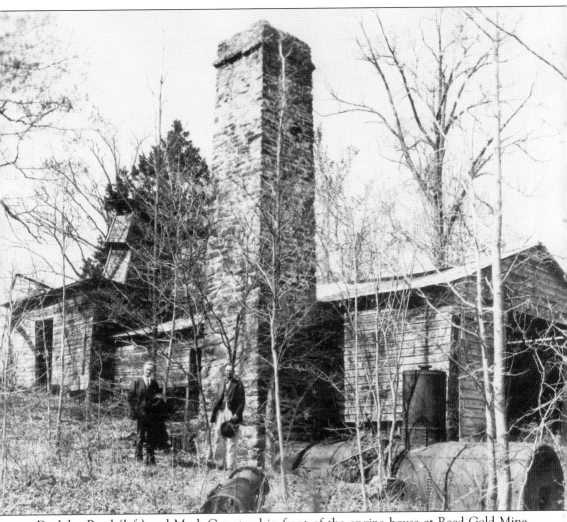

Dr. John Reed (left) and Mack Cox stand in front of the engine house at Reed Gold Mine. Cox found an eight-pound nugget at the Reed Mine in 1896. (North Carolina Archives and History.)

Carts like this were used to haul ore out of the mine.

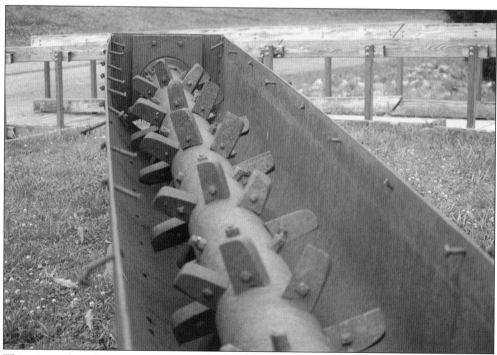

This piece of machinery, on display at the Reed Gold Mine, was used to crush ore.

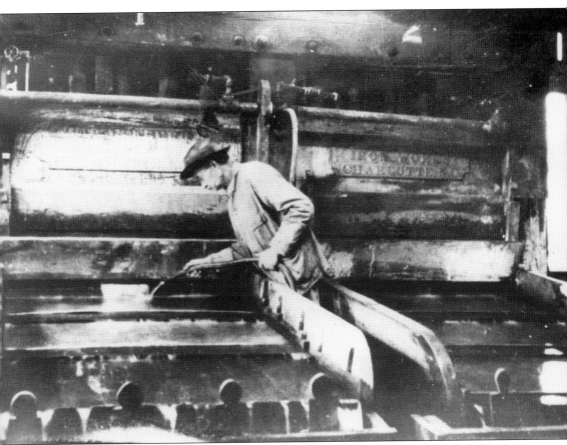

This man is spraying down the amalgamating table on the stamp mill at Reed Gold Mine.
(North Carolina Archives and History.)

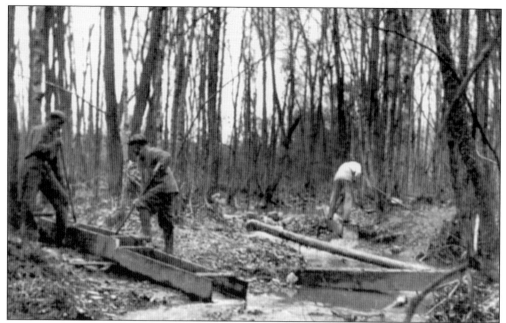

These individuals are shown sluicing for gold in Little Meadow Creek during the Great Depression. (North Carolina Archives and History.)

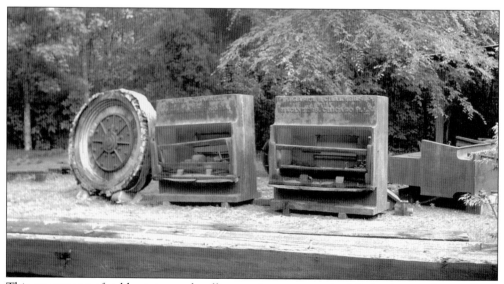

This assortment of gold-mining and milling equipment now sits idly in the woods near Reed Gold Mine.

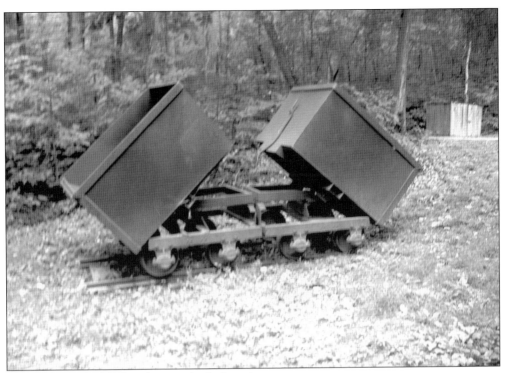

This cart was modified to dump in both directions.

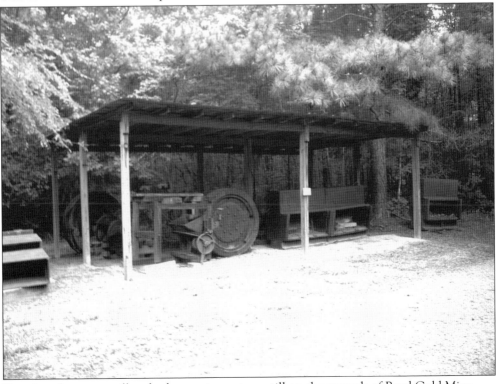

Remains of a stamp mill and other equipment are still on the grounds of Reed Gold Mine.

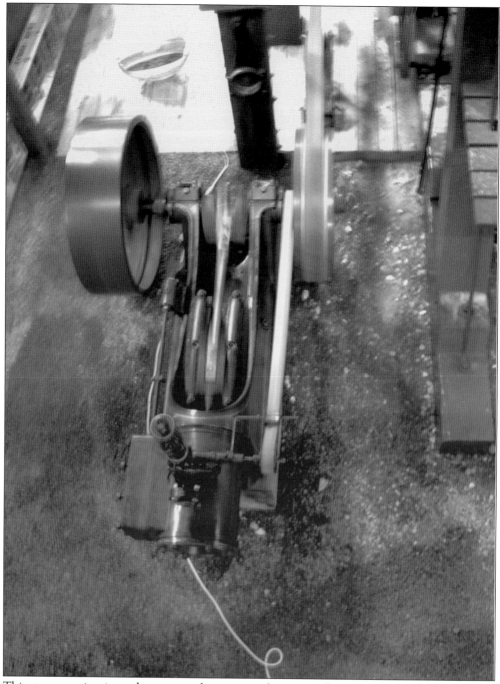

This steam engine is used to power the re-created stamp mill at the Reed Gold Mine State Historic Site.

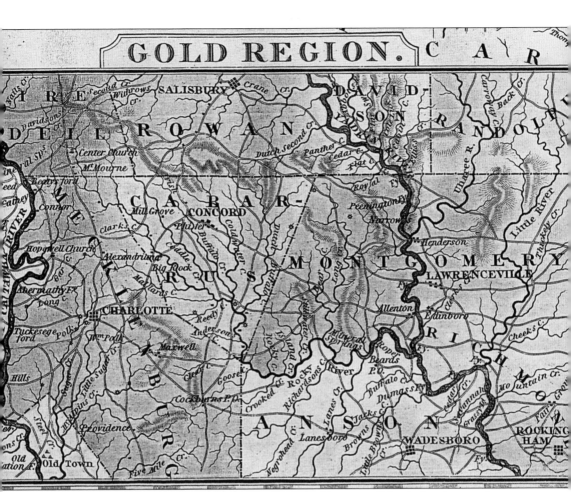

In 1833, H.L. Tanner included this inset showing the gold region of North Carolina on the map he drew of the state. (North Carolina Archives and History.)

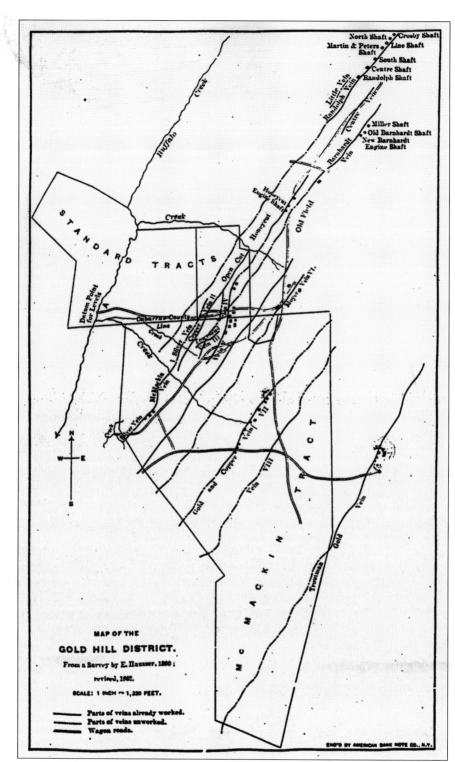

This survey made in 1860 shows the workings at Gold Hill. (North Carolina Archives and History.)

Two

GOLD HILL

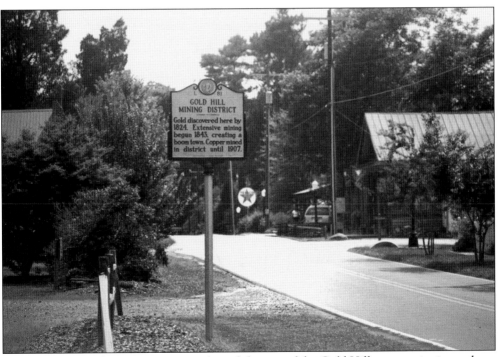

This historical marker commemorates the rich history of the Gold Hill community in southern Rowan County.

EXPLANATIONS.

WEST VEIN.

No. 1. Earnhardt Shaft—250 feet deep. ·Roofed and with 'whim' O, for raising ore, etc.

" 2. South Shaft—450 feet deep. Roofed, and with whim.

" 3. Centre Shaft—600 feet deep. Roofed; lifting by wirefed—worked by engine in Randolph Shaft house.

" 4. Randolph Shaft—750 feet deep. Housed. In this house are steam boilers, engines, drum, shafting, Cornish pumps, etc., and lifting wire rope, etc.

EAST VEIN.

No. 5. Barnhardt Shaft—350 feet deep. Under cover, with whim. In this mill-house are the steam engines, boilers, ore crushers, Chilian stones, rockers, buddles, drags, etc.; pumps, hoisting machinery, etc.

" 6. Miller Shaft (or Lowder & Co. shaft)—depth not given. It has a new whim.

" 7. Old Shaft—100 feet deep. No roof or whim.

MIDDLE VEIN.

This contains two or more shafts, formerly worked; none are now open in it. The main road through the town follows along over this vein.

No. 8. New Crosby Mill—for reducing sulphuret ores by the Crosby Patent process. This house contains the steam engine and boilers, ore crushers, ore roasters, burr mills, leach tubs, amalgamators, etc. etc.

" 9. Pure Water Shaft. Pump worked by rope from engine in No. 4. Water conveyed in pipe to reservoir No. 9.

" 10. Water Reservoir, from which good water is supplied to boilers.

" 11. Storehouse and office.

" 12. Mansion house—leased to Mr. Howse.

" 13. Stable.

" 14. Gas works for lighting new mill.

" 15. New houses for employés.

" 16. Mauney's store.

" 17. An old hotel building.

This map gives a detailed view of the mines at Gold Hill, North Carolina. (North Carolina

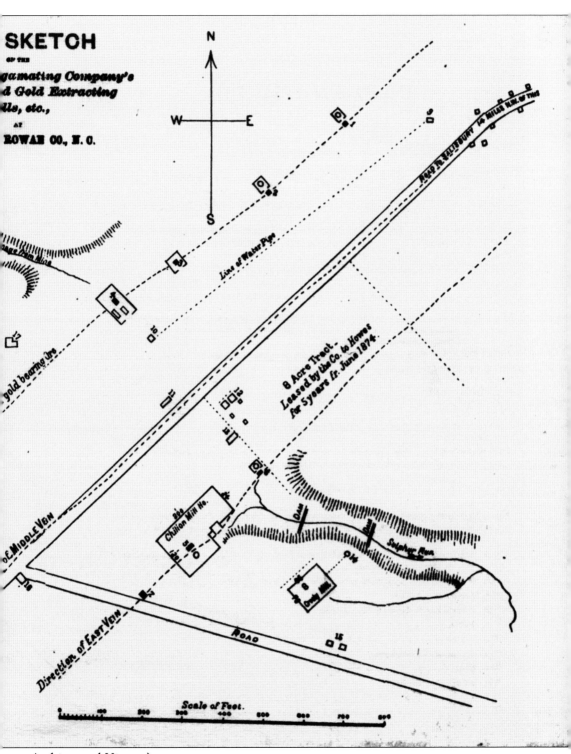

SKETCH

OF THE

...gamating Company's

...d Gold Extracting

...lls, etc.,

AT

ROWAN CO., N. C.

Line of Water Pipe

8 Acre Tract.
Leased by the Co. to Howes
for 5 years fr. June 1874.

Chilian Mill Ho.

Sulphur Run

8
Ondy Mill

Direction of Middle Vein

Direction of East Vein

ROAD

ROAD TO SALISBURY 14 MILES N.W. OF THIS

gold bearing Ore

Scale of Feet.

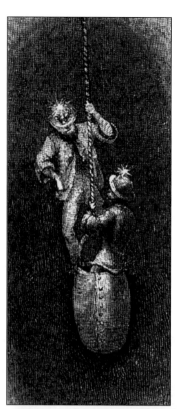

Artist Porte Crayon depicts two miners riding to the surface on a kibble at Gold Hill. (North Carolina Archives and History.)

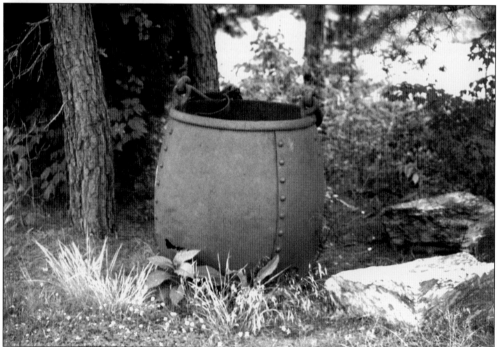

Kibbles, such as this one on display at Gold Hill Historical Park, were large metal buckets used to transport ore and men between the surface and underground at the mine.

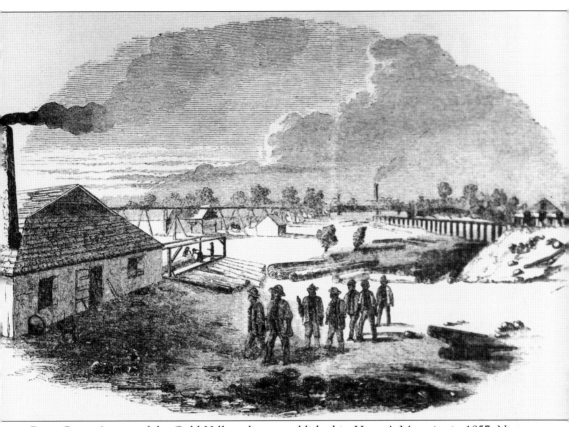

Porte Crayon's view of the Gold Hill works was published in *Harper's Magazine* in 1857. Note the timbers to be used to shore up mine shafts. (North Carolina Archives and History.)

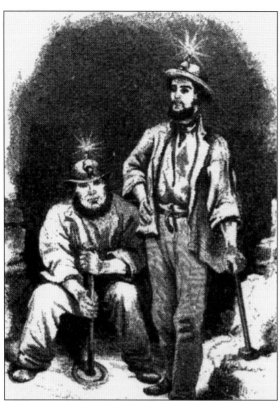

These two Cornish miners drawn by Porte Crayon are boring a hole in a vein of rock in preparation for blasting. (North Carolina Archives and History.)

Shown here is the old log-rocker method of extracting gold from ore. This *c.* 1860 photo was taken at Gold Hill. (North Carolina Archives and History.)

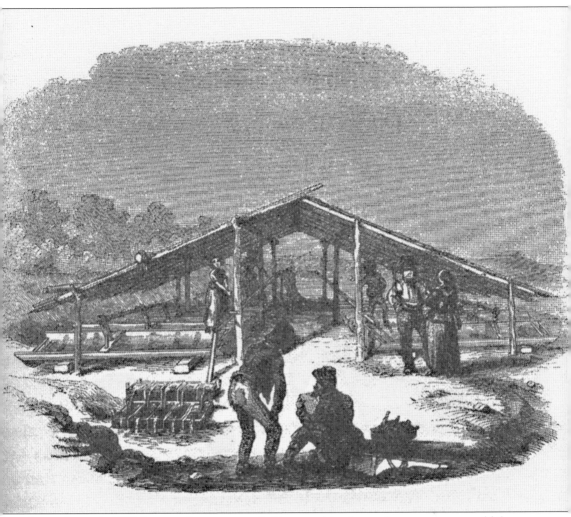

Porte Crayon's 1857 drawing shows young children working log rockers to separate gold from gravel. (North Carolina Archives and History.)

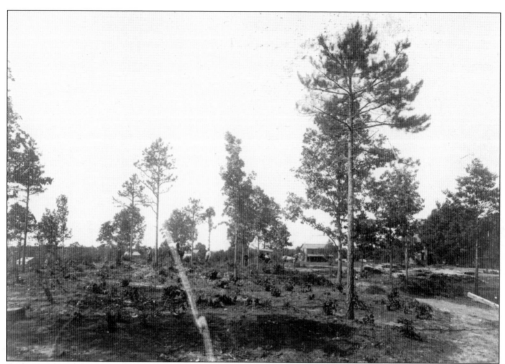

Mine management, seen in the distance, surveys the scene at Gold Hill, *c.* 1890. (North Carolina Archives and History.)

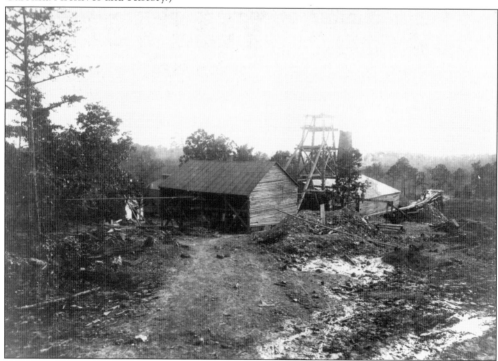

Shown is an exterior view of the mineshaft at Gold Hill in 1890. (North Carolina Archives and History.)

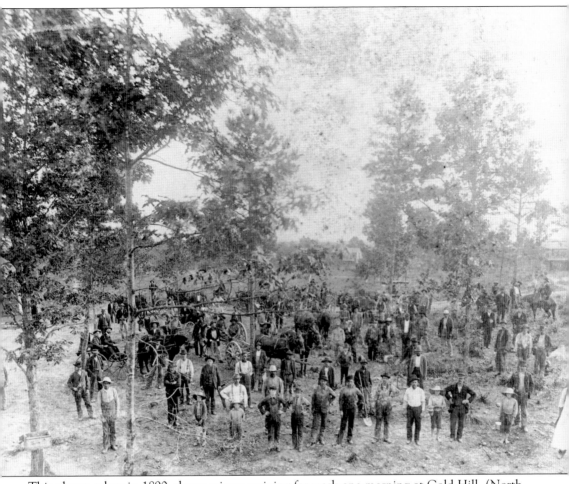

This photo, taken in 1890, shows miners arriving for work one morning at Gold Hill. (North Carolina Archives and History.)

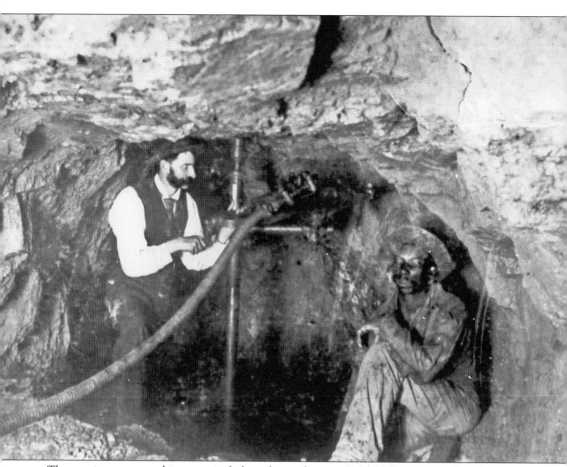

These miners are working a vein below the surface at Gold Hill, c. 1896. (North Carolina Archives and History.)

This miner is working at the Whitney Mine at Gold Hill. (North Carolina Archives and History.)

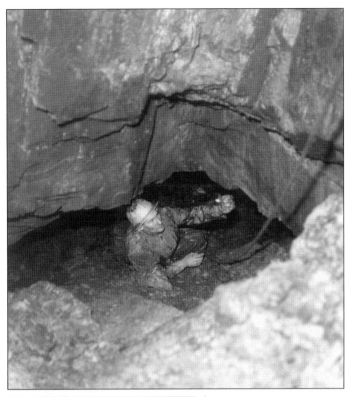

Shown here is the opening to the Whitney Mine at Gold Hill. (North Carolina Archives and History.)

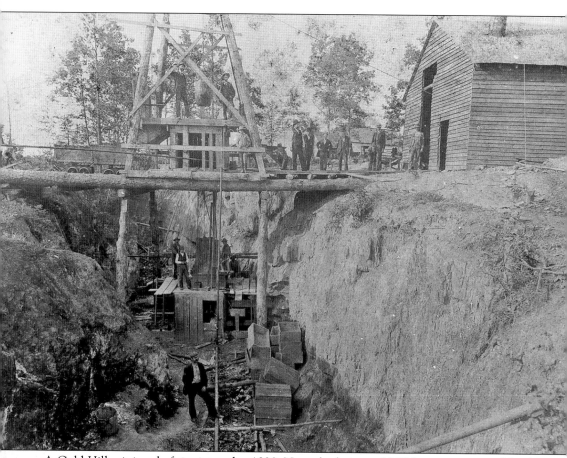

A Gold Hill mining shaft is pictured *c.* 1890. Note the hoist and kibble at top center. (North Carolina Archives and History.)

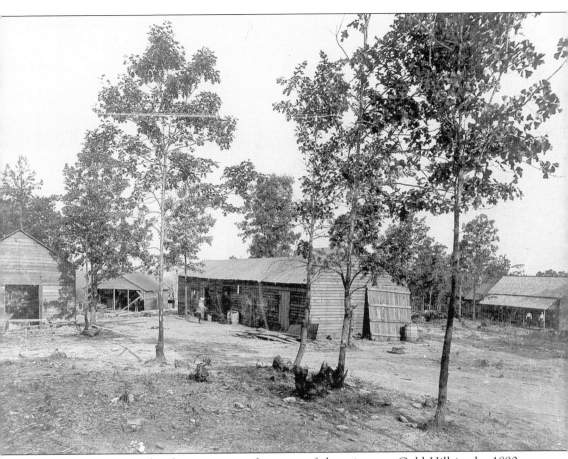

These buildings served as living quarters for many of the miners at Gold Hill in the 1890s. (North Carolina Archives and History.)

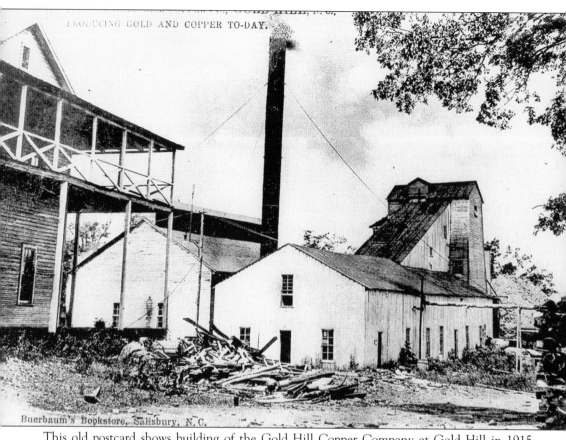

This old postcard shows building of the Gold Hill Copper Company at Gold Hill in 1915. (North Carolina Archives and History.)

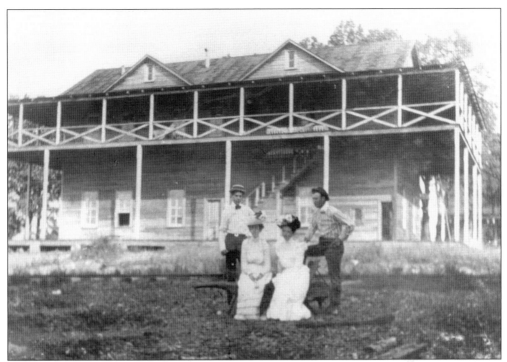

Employees pose in front of the office building at Gold Hill, *c.* 1900. (North Carolina Archives and History.)

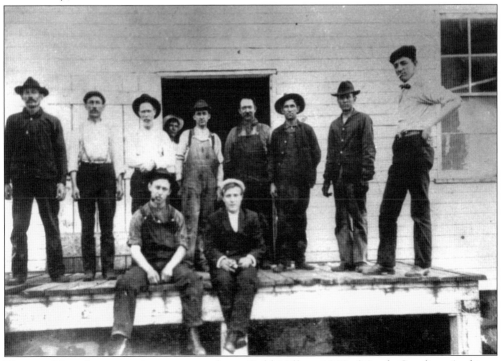

The machine shop crew is seen at work on Gold Hill, *c.* 1890. (North Carolina Archives and History.)

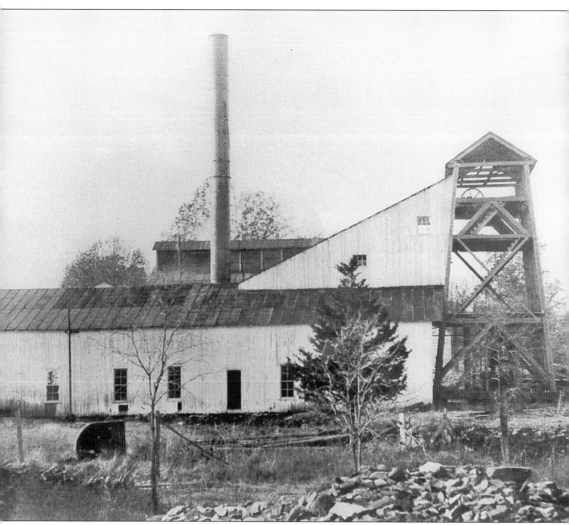

This is an exterior view of the Barnhardt Shaft at Gold Hill, *c.* 1890. (North Carolina Archives and History.)

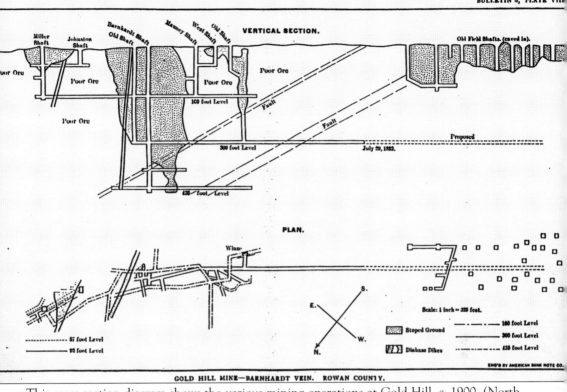

GOLD HILL MINE—BARNHARDT VEIN. ROWAN COUNTY.

This cross-section diagram shows the various mining operations at Gold Hill, *c.* 1900. (North Carolina Geological Survey.)

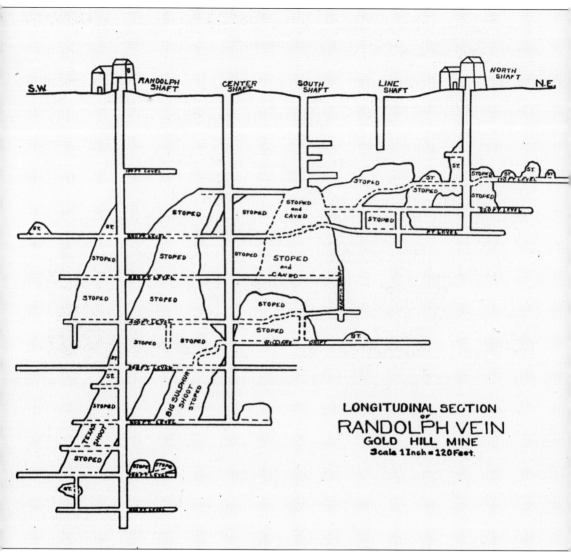

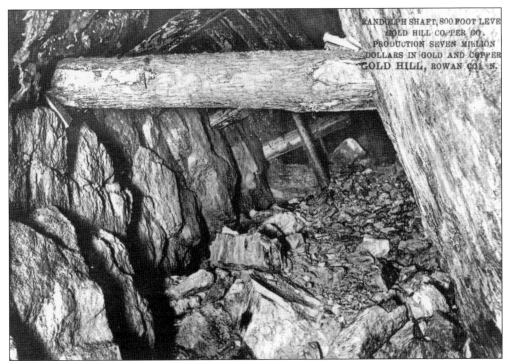

Shown here is a view of the 800-foot level of the Randolph Shaft at Gold Hill. This was supposedly the deepest and richest gold mine east of the Mississippi. (North Carolina Archives and History.)

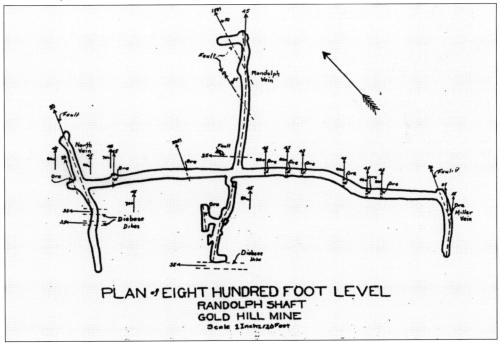

This diagram shows the layout of the mine 800 feet below the surface in the Randolph Shaft at Gold Hill. (North Carolina Geological Survey.)

Shown is the shaft of the Union Gold Mine at Gold Hill. (North Carolina Archives and History.)

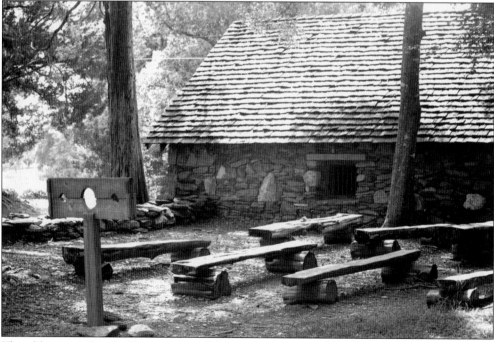

The old stone jail and pillory are part of the restoration at Gold Hill Historical Park.

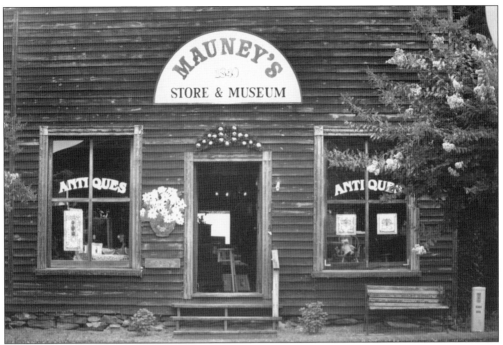

Mauney's Store, established in 1840, served miners during the boomtown era of Gold Hill. Today a museum is located inside the store.

A mineshaft entrance is shown at Gold Hill Historical Park with a Chilean mill in the background.

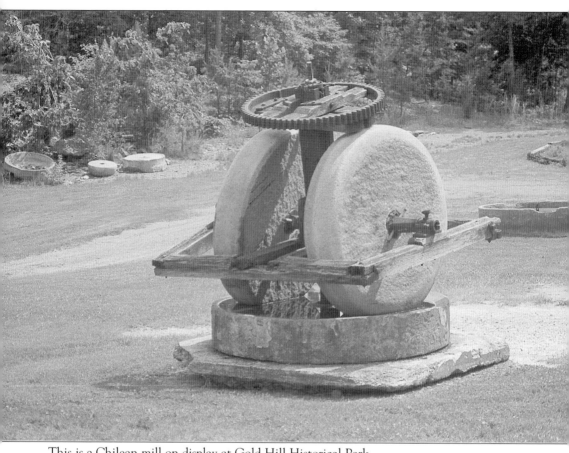

This is a Chilean mill on display at Gold Hill Historical Park.

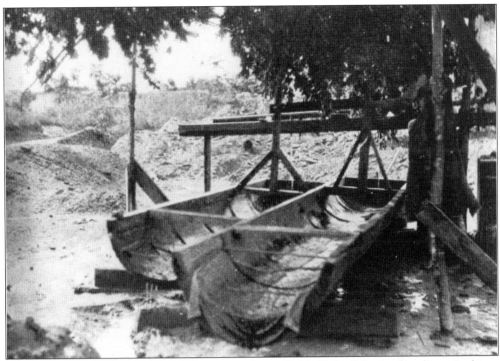

Old-style log washers like these were used at Gold Hill. (North Carolina Archives and History.)

Pictured here is an amalgamator, c. 1891. (North Carolina Archives and History.)

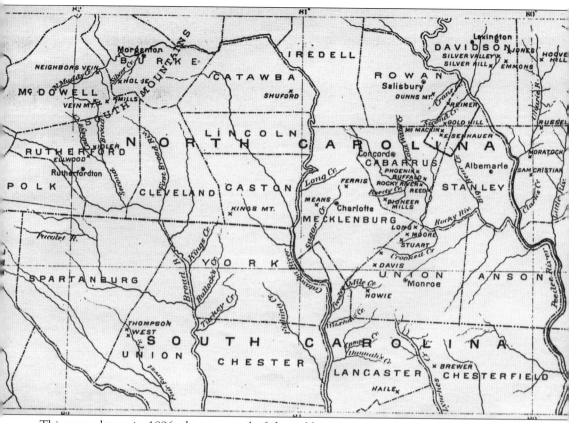

This map, drawn in 1896, shows several of the gold-mining operations across Central North Carolina. (North Carolina Geological Survey.)

Three

UWHARRIE GOLD MINES

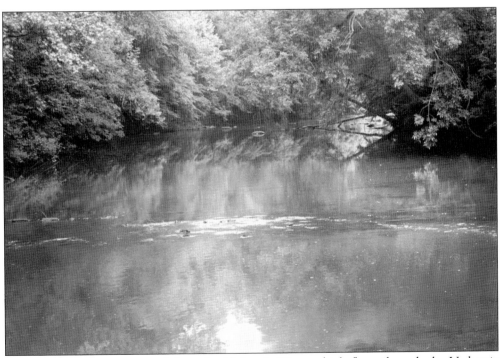

Much gold has been extracted from the Uwharrie River, which flows through the Uwharrie Mountains of central North Carolina. This scene is in Randolph County.

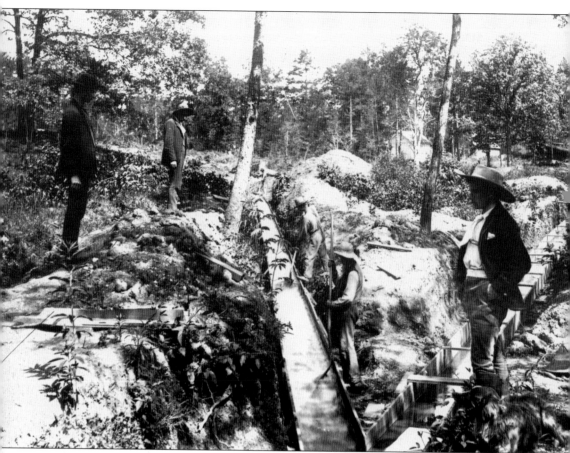

Workers are shown operating sluices at the Parker Gold Mine in Stanly County. (North Carolina Archives and History.)

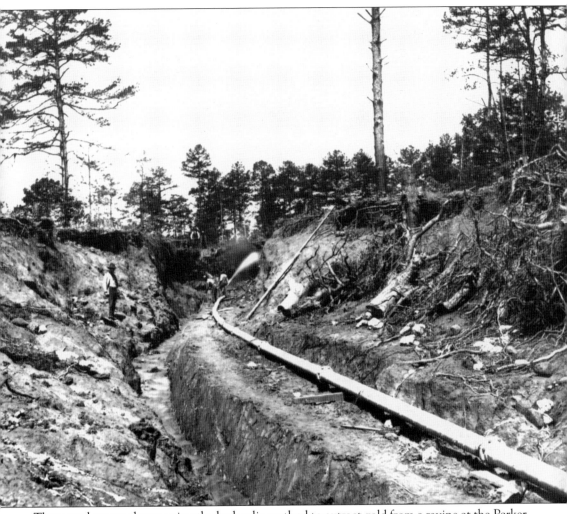

These workers are shown using the hydraulic method to extract gold from a ravine at the Parker Gold Mine in Stanly County, c. 1900. (North Carolina Archives and History.)

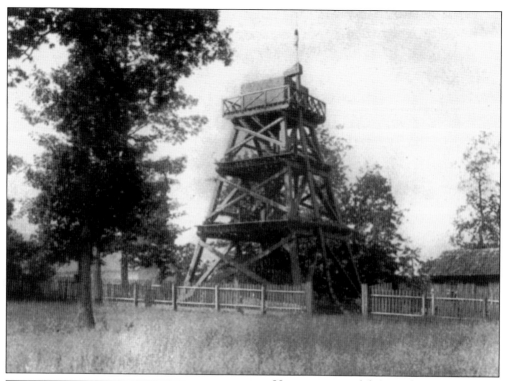

Here is a view of the stand at Stanly County's Parker Mine. (North Carolina Archives and History.)

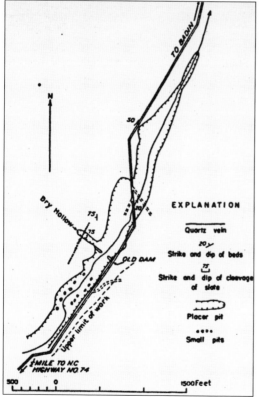

This diagram shows one of the adits at the Parker Mine, c. 1896. (North Carolina Geological Survey.)

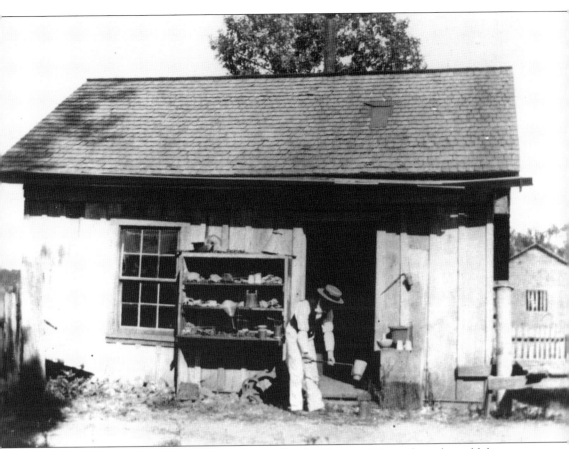

Seen is the assay office at New London in Stanly County. Miners brought gold here to determine its worth. (North Carolina Archives and History.)

Miners worked placer deposits in streams such as this one all across the Uwharrie Mountains.

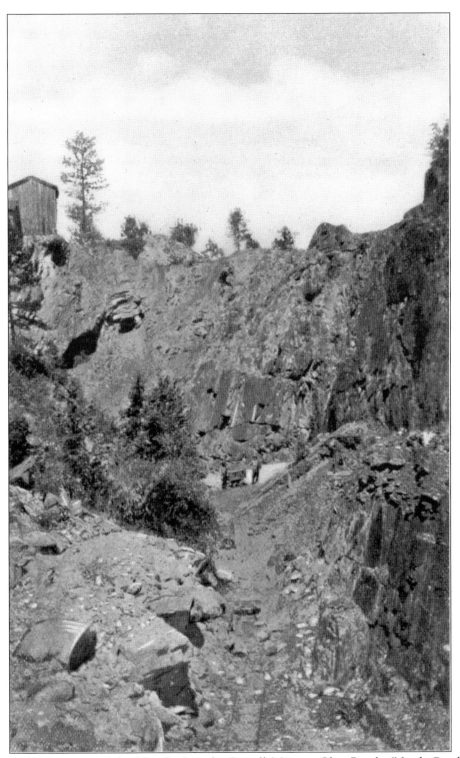

This c. 1897 view is of the "Big Cut" at the Russell Mine at Glen Brook. (North Carolina Archives and History.)

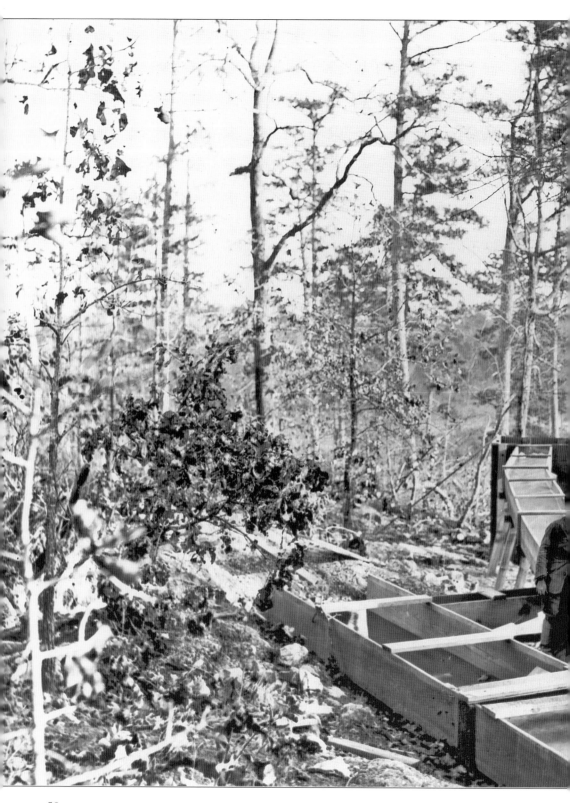

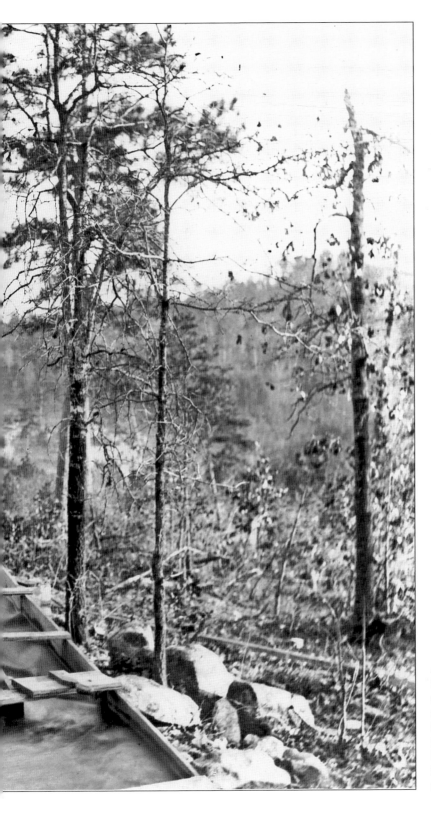

A worker oversees the water-tank and sluice boxes at the Sam Christian Mine in Montgomery County. (North Carolina Archives and History.)

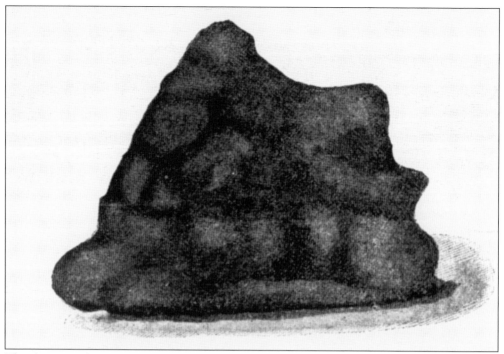

This four-pound nugget was found at Montgomery County's Sam Christian Mine. "The mine has gained something more than a local reputation," wrote Washington Caruthers Kerr and George B. Hanna in 1896, "and has been productive of remarkably large and fine nuggets." (North Carolina Archives and History.)

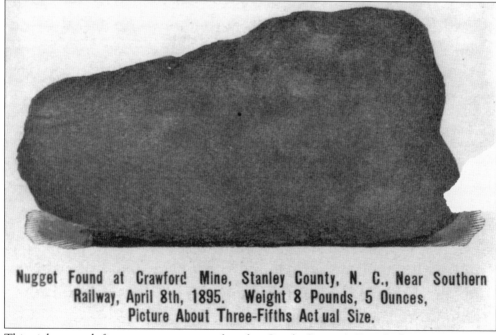

Nugget Found at Crawford Mine, Stanley County, N. C., Near Southern Railway, April 8th, 1895. Weight 8 Pounds, 5 Ounces, Picture About Three-Fifths Actual Size.

This eight-pound, five-ounce nugget was found at Stanly County's Crawford Mine on April 8, 1895. (North Carolina Archives and History.)

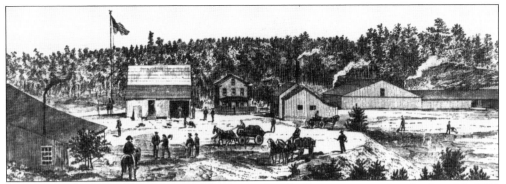

This artist's exterior view of the Crowell Mine in Stanly County appeared in the June 25, 1881 edition of the *New York Daily Graphic*. (North Carolina Archives and History.)

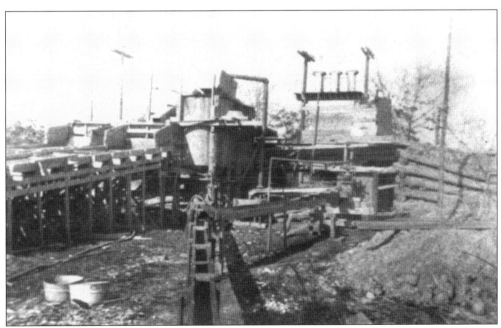

A gold recovery plant at the Black Ankle Mine in Montgomery County is pictured *c.* 1900. (North Carolina Archives and History.)

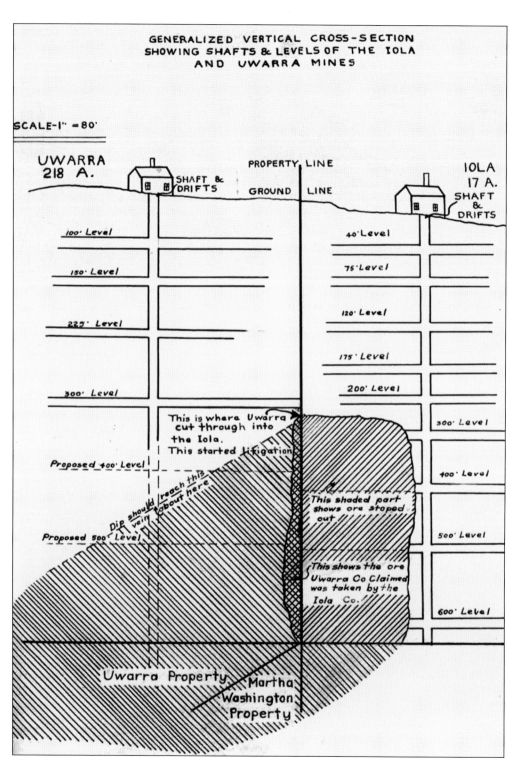

This drawing shows a cross-section view of the Uwarra and Iola Mines in Stanly County. (Stanly County Public Library.)

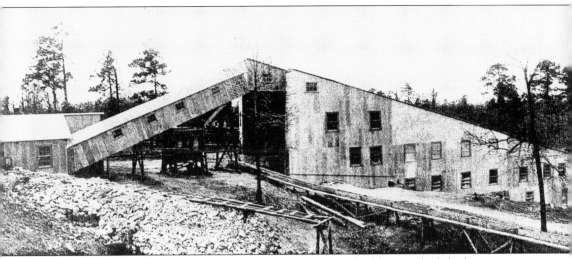

This photo of the Uwarra Mining Company shows the crusher building on the left, the conveyor building in the center, and the mill on the right. (North Carolina Archives and History.)

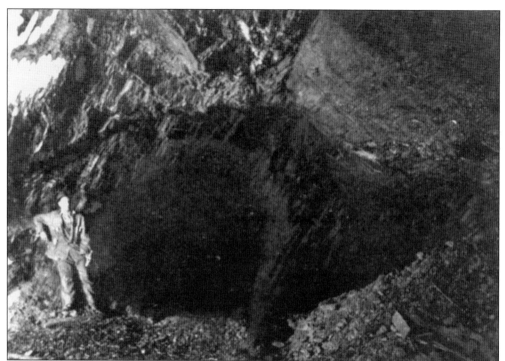

Miners stand at the 250-foot level at the Coggins Mine in 1925. (North Carolina Archives and History.)

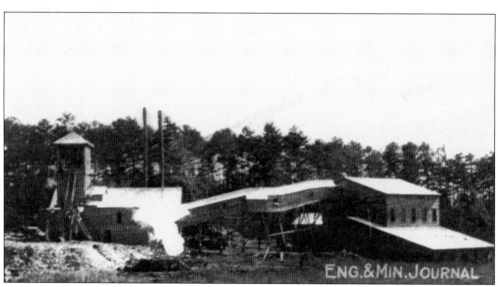

An exterior view of the Coggins Mine near Eldorado is seen here. (North Carolina Archives and History.)

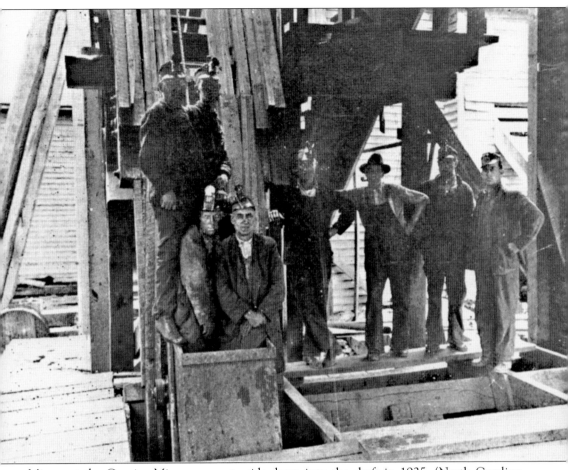

Miners at the Coggins Mine prepare to ride down into the shaft in 1925. (North Carolina Archives and History.)

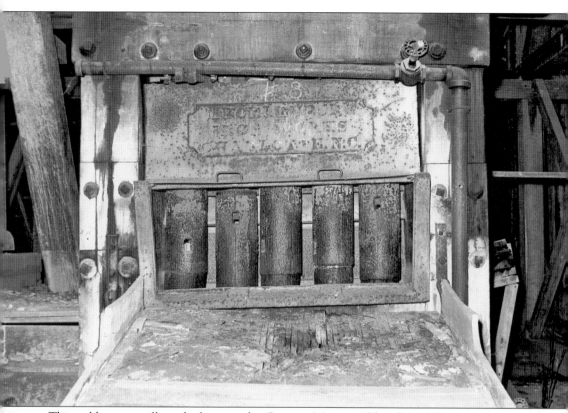

This gold-stamp mill crushed ore at the Coggins Mine at Eldorado in Montgomery County. (North Carolina Archives and History.)

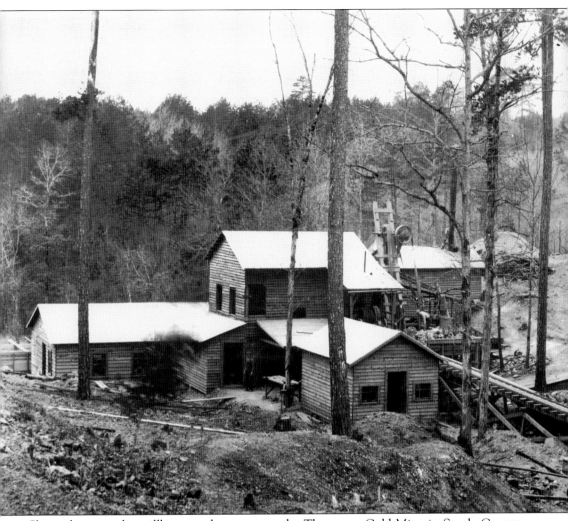

Shown here are the millhouse and tramway at the Thompson Gold Mine in Stanly County. (North Carolina Archives and History.)

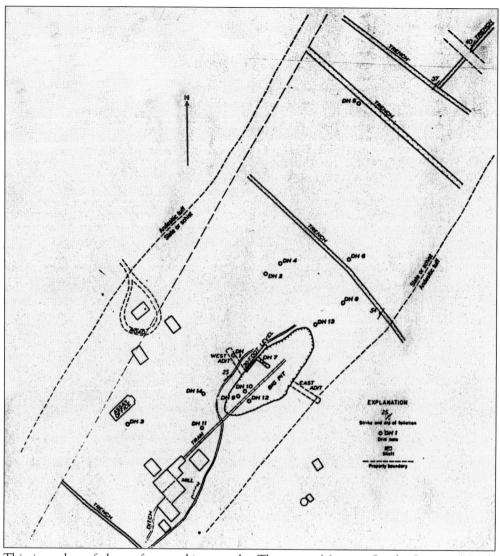

This is a plan of the surface workings at the Thompson Mine in Stanly County. (North Carolina Geological Survey.)

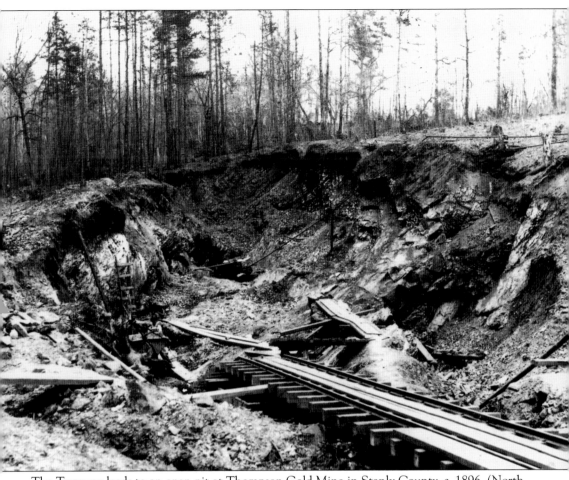

The Tramway leads to an open pit at Thompson Gold Mine in Stanly County, c. 1896. (North Carolina Archives and History.)

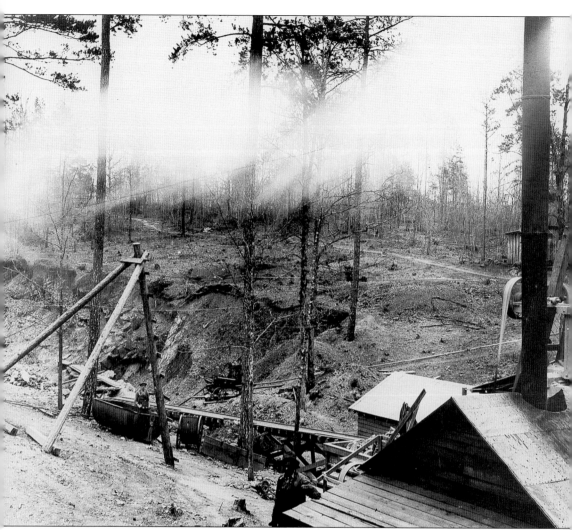

This exterior view shows the Thompson Mine in Stanly County. (North Carolina Archives and History.)

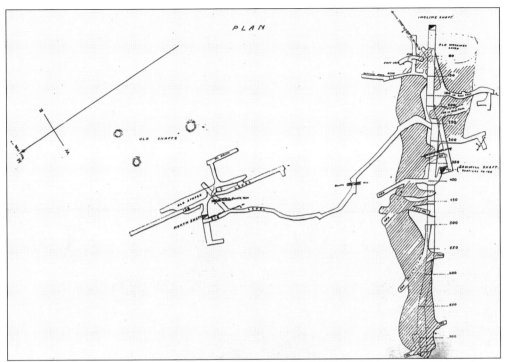

Shown is a plan of the Silver Hill Mine, *c.* 1890. (North Carolina Archives and History.)

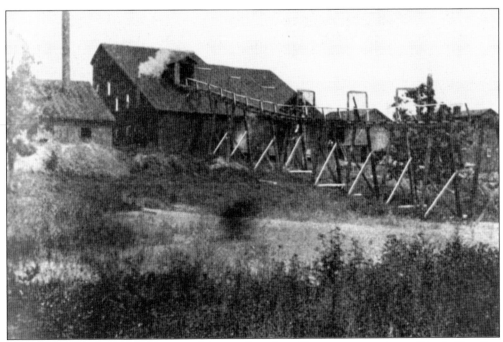

The mill and smelter at the Emmons Mine in Davidson County are seen here. (North Carolina Archives and History.)

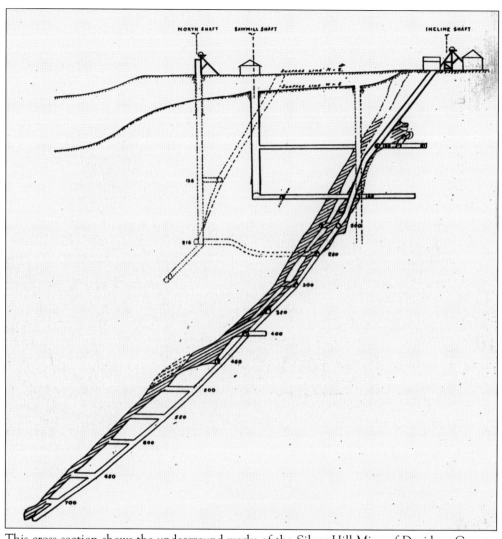

This cross-section shows the underground works of the Silver Hill Mine of Davidson County, c. 1860. (North Carolina Archives and History.)

Gold was found in numerous locations across the Uwharrie Mountains of central North Carolina.

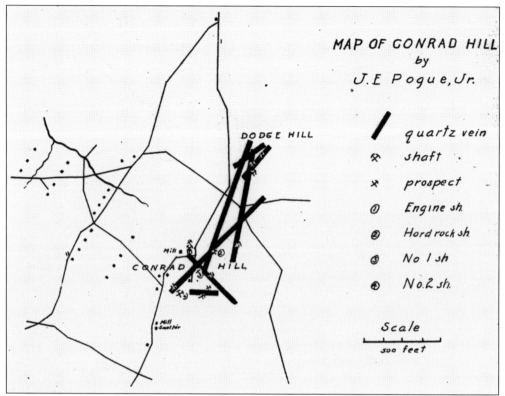

This map shows the various workings at the Conrad Hill Gold Mine in Davidson County, near Lexington. (North Carolina Geological Survey.)

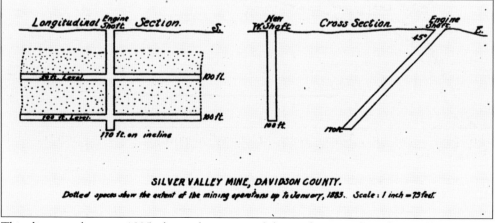

This diagram, drawn c. 1895, shows the extent of the workings at the Silver Valley Mine in Davidson County. (North Carolina Geological Survey.)

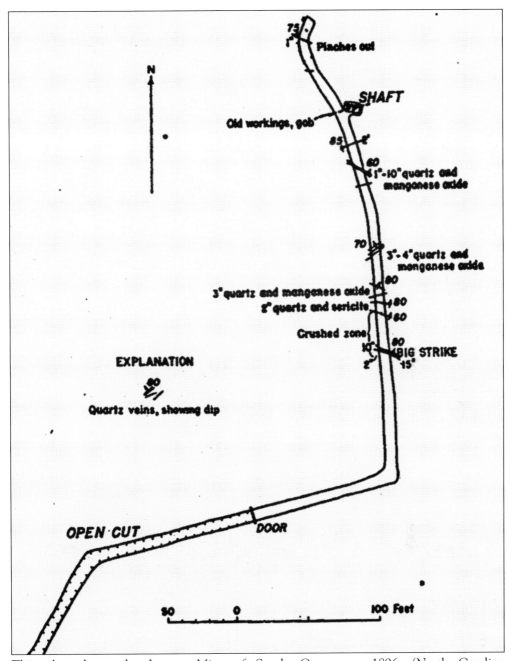

This plan shows the Ingram Mine of Stanly County, *c.* 1896. (North Carolina Geological Survey.)

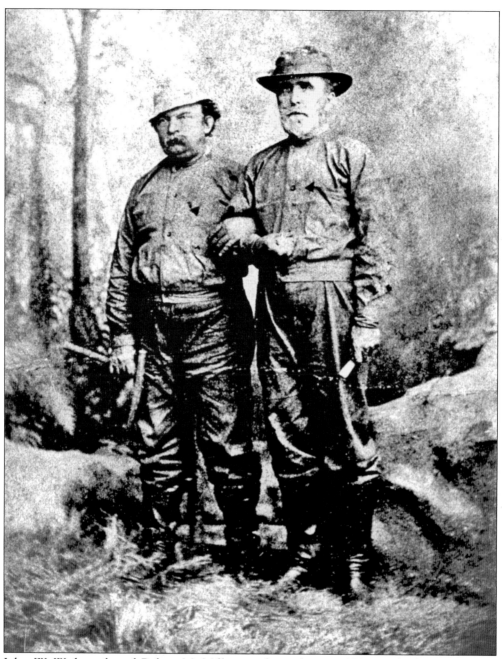

John W. Wadsworth and Robert M. Miller are shown here in 1882, ready for work in the Rudisill Gold Mine in Charlotte. (North Carolina Archives and History.)

Four

OTHER PIEDMONT GOLD MINES

Gold mining is an important part of the folklore of the Charlotte area. The University of North Carolina at Charlotte chose "49ers" as the name for their athletic teams.

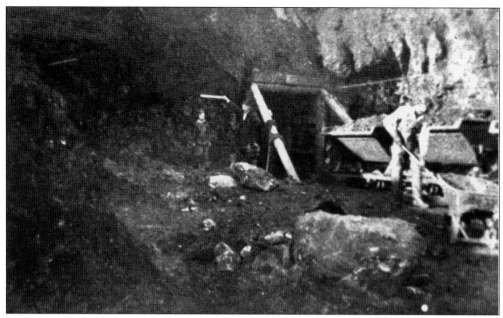

This rare image shows miners hard at work in the Norlina Mine. This was one of the mines where ore was extracted from the Eastern Slate Belt in Nash, Franklin, and Halifax Counties. (North Carolina Archives and History.)

This photo shows the shaft and abandoned workings at the Nash Mine in Cabarrus County. (North Carolina Archives and History.)

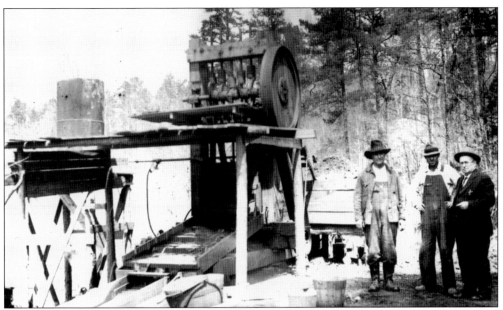

These three men are standing beside a stamp mill in Cabarrus County, *c.* 1830. (North Carolina Archives and History.)

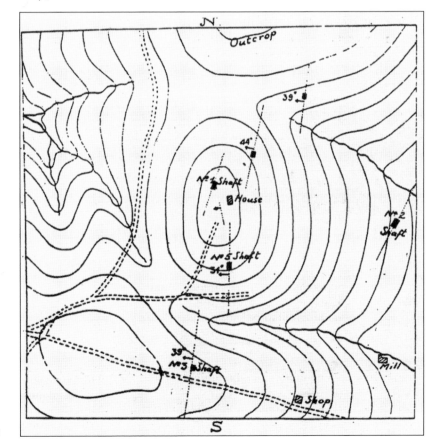

This map shows the location of several structures at the Rocky River Gold Mine in Cabarrus County. (North Carolina Archives and History.)

BRUSH HILL

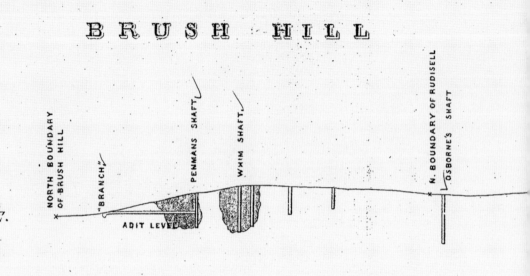

NNE.

The shaded parts show the ground worked away
on some of the principal "bunches".

This chart shows a cross-section of the Rudisill and Brush Hill Gold Mines in Charlotte.

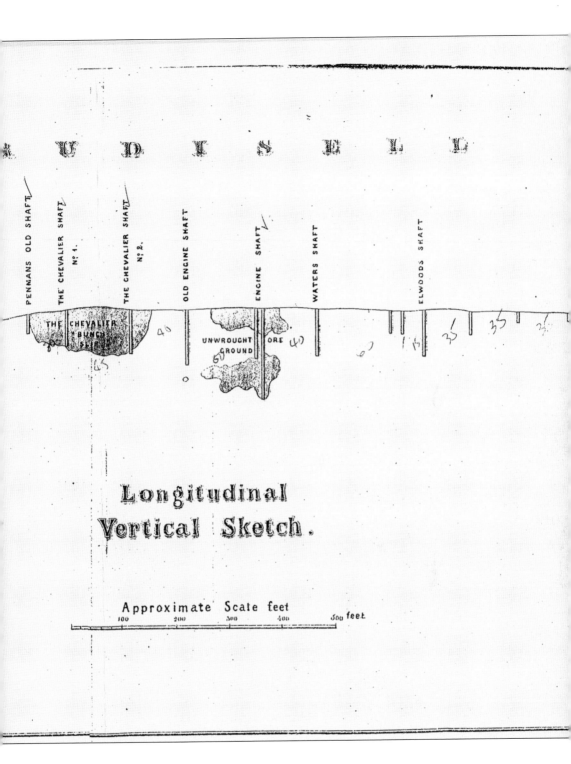

Longitudinal
Vertical Sketch.

Approximate Scale feet

100 200 300 400 500 feet

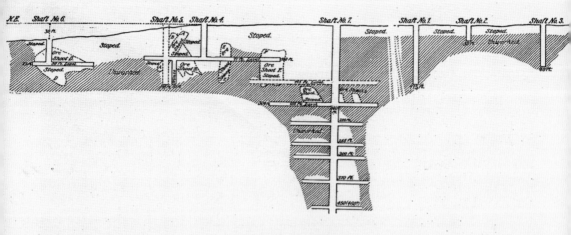

ST. CATHERINE MINE.

A longitudinal vertical (in part) section, drawn from the notes of Messrs. G. W. Pitcher and Wm. Lewis, 1883. Scale : 1 inch = 150 feet. The ore shoot A is found on the foot wall and dips northward ; shoot B is found in the hanging wall and dips southward ; shoots E & F probably dip southward, but have not been explored sufficiently to permit of a positive statement. Shaft No. 5 is considerably in front of No. 4, and does not enter either the level or vein. The distance between shafts 1 and 7 is 1,300 feet. The section runs N. E. by S. W.

This diagram shows the underground workings of the St. Catherine Mine in Charlotte in 1883. (North Carolina Geological Survey.)

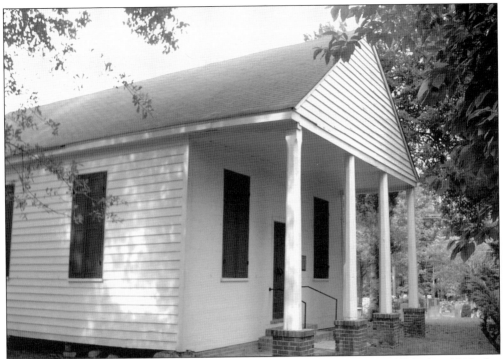

These images show St. Joseph's Catholic Church in Gaston County. Established in 1843, this is the oldest Catholic church structure in North Carolina. The church was built for the use of the large number of Irishmen who came to the area to work in the gold mines.

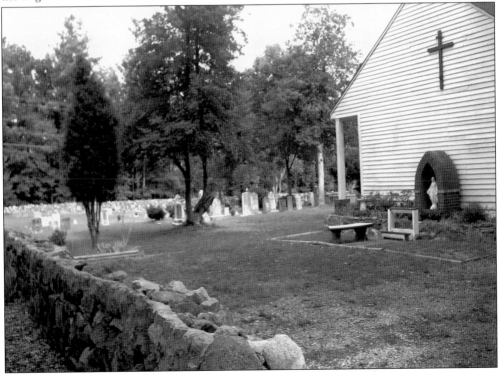

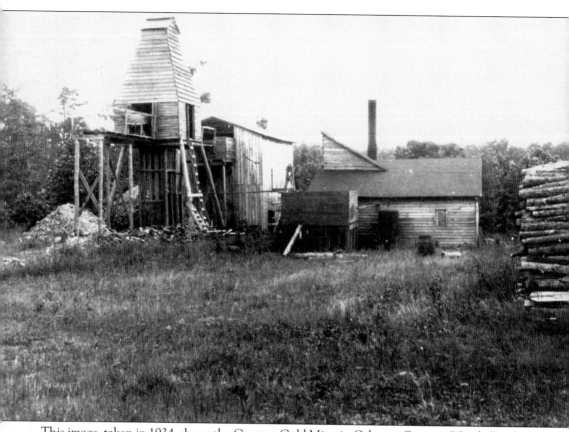

This image, taken in 1934, shows the Crayton Gold Mine in Cabarrus County. (North Carolina Archives and History.)

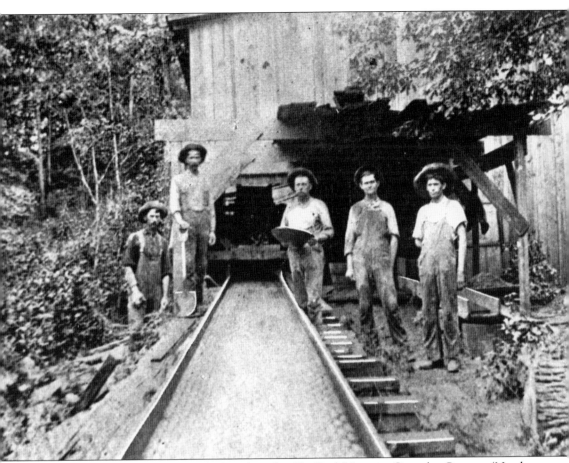

These miners are working a riffle board at the Shufford Mine in Catawba County. (North Carolina Archives and History.)

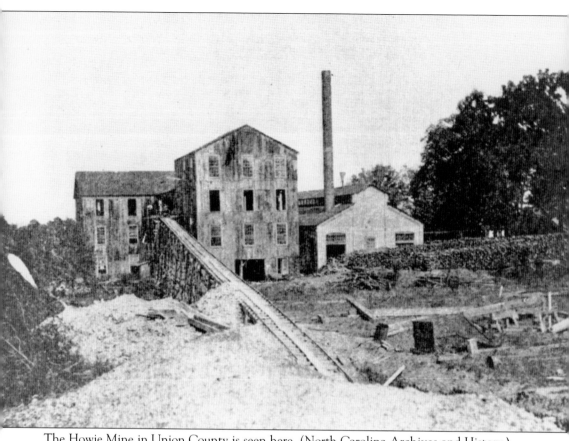

The Howie Mine in Union County is seen here. (North Carolina Archives and History.)

A Chilean mill was set up to process ore at Roger's Prospect in Union County. This photo shows the interesting machinery as it appeared in 1934. (North Carolina Archives and History.)

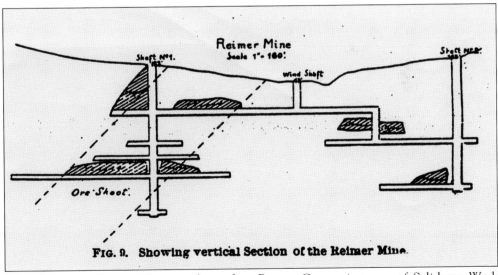

FIG. 9. Showing vertical Section of the Reimer Mine.

The Reimer, or Rymer, Mine was located in Rowan County just east of Salisbury. Work started here in the 1850s and continued into the early 20th century. (North Carolina Geological Survey.)

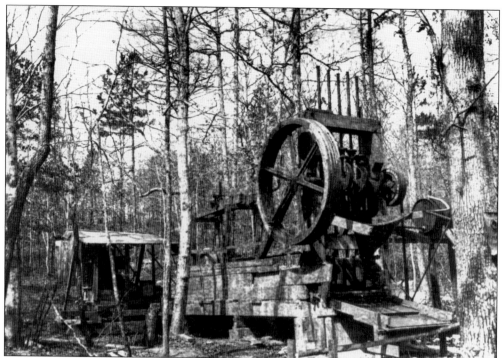

This photo, taken in 1934, shows a gold mill with a five-stamp battery operating near Bost's Mill in Cabarrus County. (North Carolina Archives and History.)

Prospectors have had some luck through the years panning for gold in the headwaters of Lick Creek in Lee County.

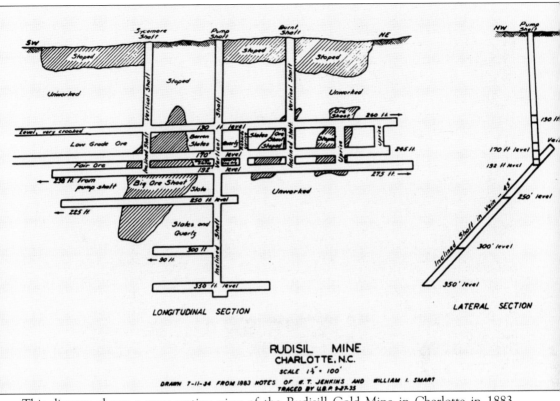

SW Sycamore Shaft Pump Shaft Burnt Shaft NE NW Pump Shaft

Stoped Stoped Stoped 130 ft

Unworked Stoped Unworked Vein

Ore Sheet 260 ft

Level, very crooked Low Grade Ore 130 ft level Barren Slates Slates Ore Sheet Sheet 245 ft 170 ft level

170 level Stoped 192 ft level

Fair Ore 198 ft 275 ft

238 ft from pump shaft Big Ore Sheet Slate Unworked 250' level

225 ft 250 ft level

Slates and Quartz 300' level

300 ft

90 ft

355 ft level 350' level

Vertical Shaft Inclined Shaft Pump Shaft Vertical Shaft Inclined Shaft Vertical Shaft Vertical Shaft Inclined Shaft Inclined Shaft in Vein

LONGITUDINAL SECTION LATERAL SECTION

RUDISIL MINE
CHARLOTTE, N.C.
SCALE 1½" = 100'
DRAWN 7-11-34 FROM 1883 NOTES OF W. T. JENKINS AND WILLIAM I. SMART
TRACED BY U.B.P. 9-27-35

This diagram shows a cross-section view of the Rudisill Gold Mine in Charlotte in 1883. (North Carolina Geological Survey.)

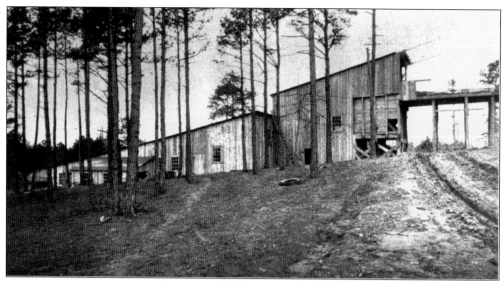

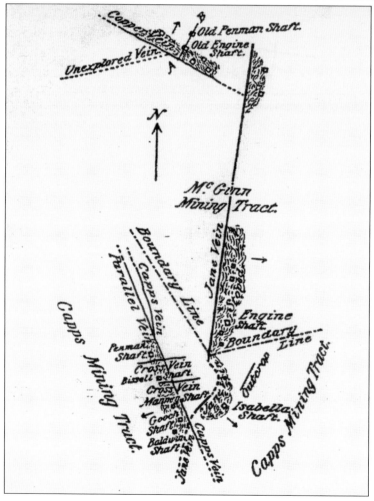

The Rudisill Mine in Charlotte is pictured here. (North Carolina Archives and History.)

This map shows the workings at the Capps and McGinn Gold Mines in Charlotte, c. 1900. (North Carolina Geological Survey.)

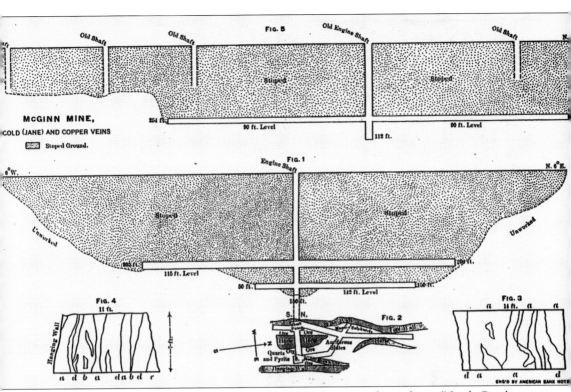

A cross-section of the McGinn Mine in Mecklenburg County is shown here. (North Carolina Geological Survey.)

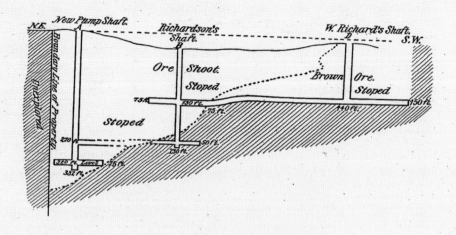

CATAWBA (KING'S MOUNTAIN) MINE.

A longitudinal vertical (in part) section, drawn largely from the notes of Northey and Fidler,
1883. Scale : 1 inch — 200 feet.

This diagram shows the mining operations at the Catawba Gold Mine near Kings Mountain.
(North Carolina Geological Survey.)

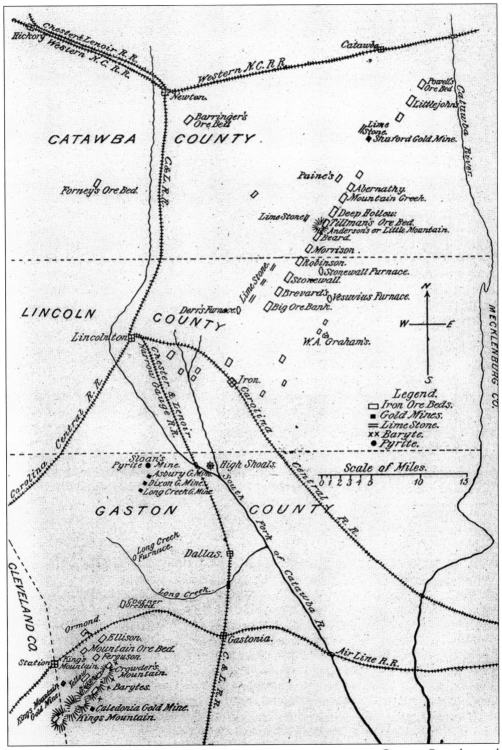

Kerr and Hanna drew this map of the various mining operations in Gaston, Catawba, and Lincoln Counties in 1896. (North Carolina Geological Survey.)

93

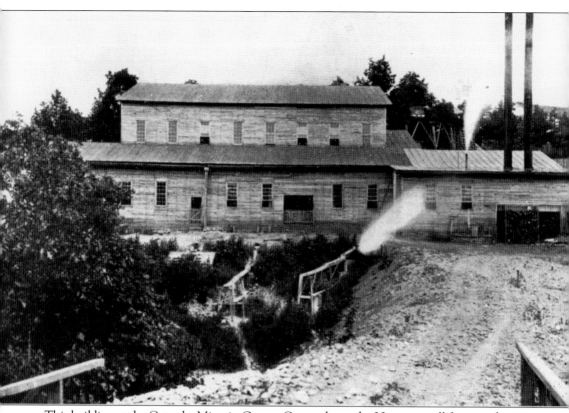

This building at the Catawba Mine in Gaston County housed a 30-stamp mill for pounding ore. (North Carolina Archives and History.)

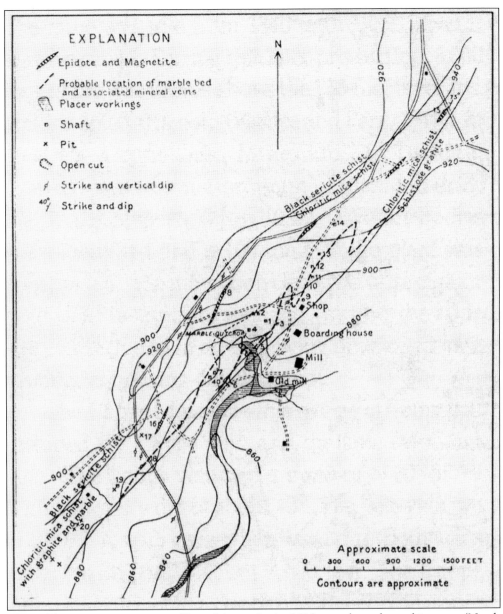

The gold-mining operations at Kings Mountain in 1913 are charted on this map. (North Carolina Geological Survey.)

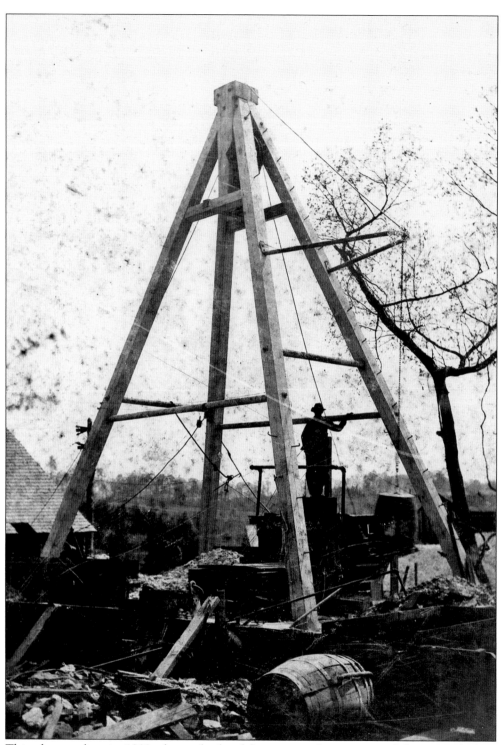

This photo, taken in 1902, shows the head-frame over the opening of the main shaft at the Phoenix Mine. Note the mechanism used to dump buckets. (North Carolina Archives and History.)

This 1905 photo shows office and living quarters used by Miami Mining Company at the Phoenix Gold Mine. The man on the steps is believed to be company president Charles Chapin. (North Carolina Archives and History.)

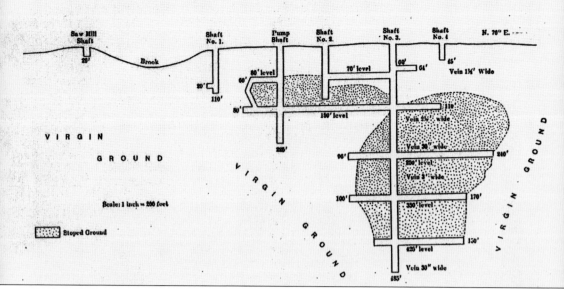

This diagram shows the workings at the Phoenix Mine *c.* 1890. (North Carolina Geological Survey.)

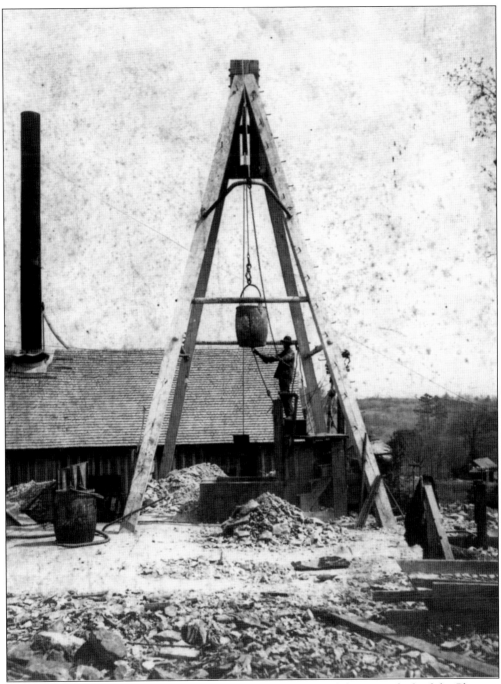

Another view is seen here of the head-frame over the collar of the main shaft of the Phoenix Gold Mine. The building in the background housed various machinery, including compressors, boilers, hoists, and electric dynamos. (North Carolina Archives and History.)

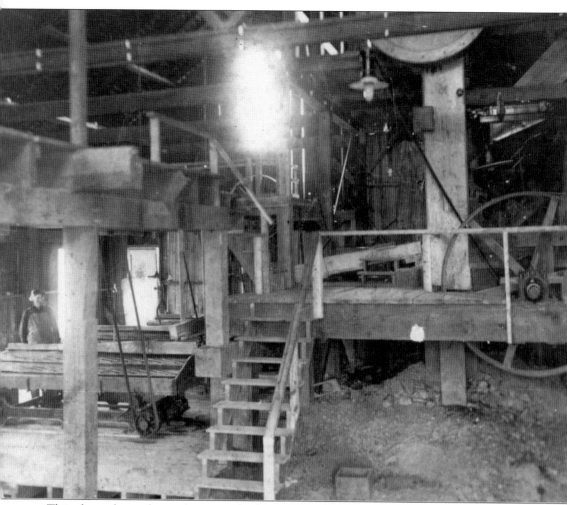

This photo shows the workings inside the stamp mill at the Phoenix Mine in 1902. (North Carolina Archives and History.)

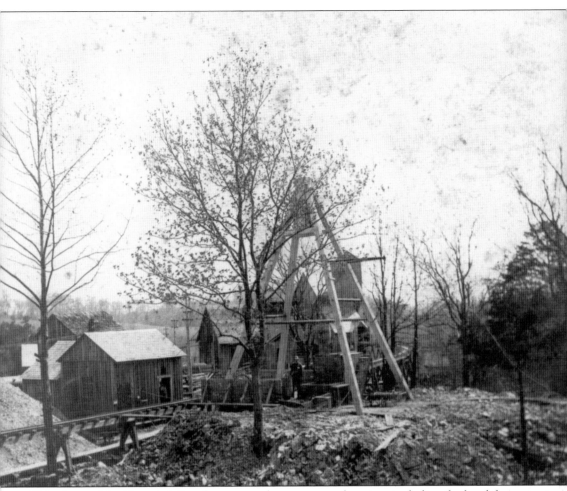

This photo of the Phoenix Mine shows several structures at the mine, including the head-frame and the tramway. (North Carolina Archives and History.)

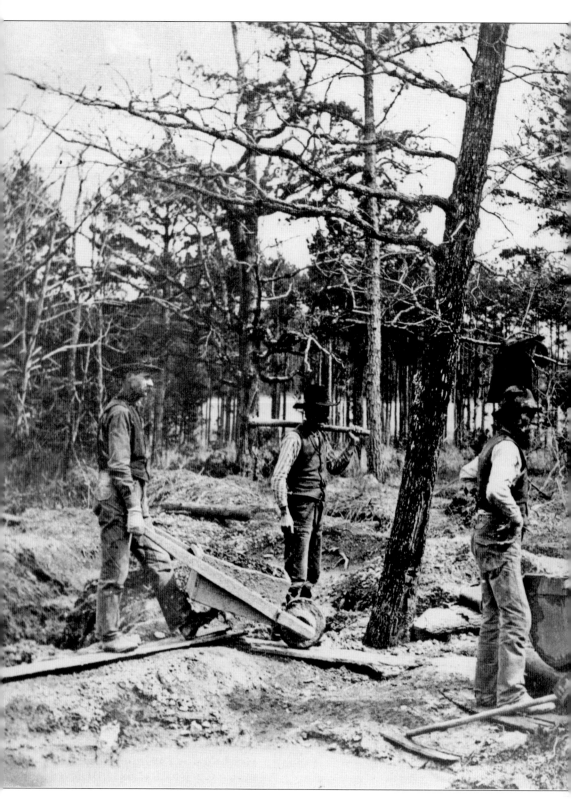

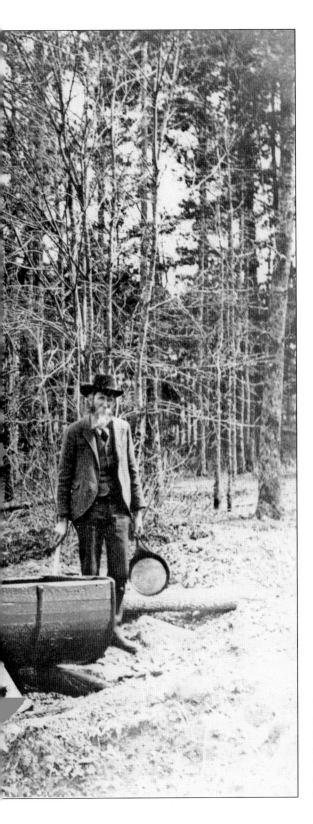

This photo, taken c. 1880, shows several miners getting ready to go to work at a gold mine in Cabarrus County. Note some of their tools, which include picks, wheelbarrows, a half-barrel rocker, and a frying pan. (North Carolina Archives and History.)

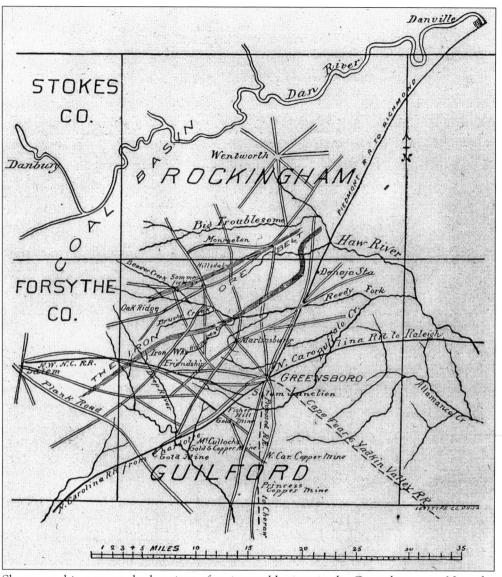

Shown on this map are the locations of various gold mines in the Greensboro area. Note the several mines indicated south of town. (North Carolina Geological Survey.)

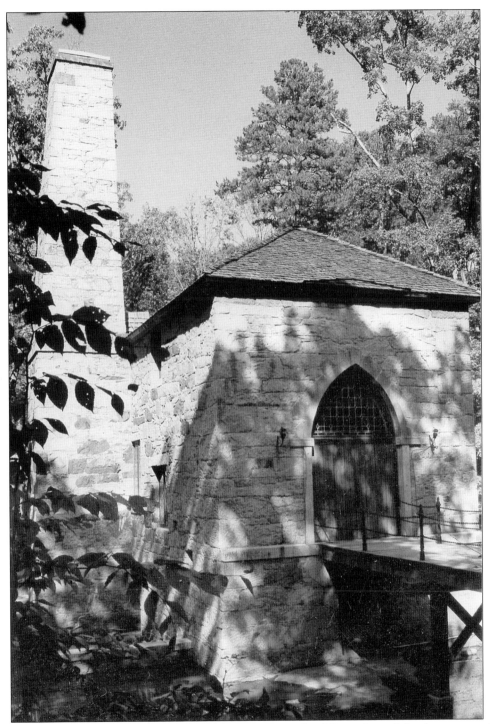

The McCulloch Gold Mill is located near Jamestown, south of Greensboro. It has been restored and is today known as Castle McCulloch. Today it is a popular meeting site used for a variety of functions, including weddings. Dr. Charles Jackson investigated the McCulloch gold mine in 1853. He called this mine "the most valuable gold mine in the state."

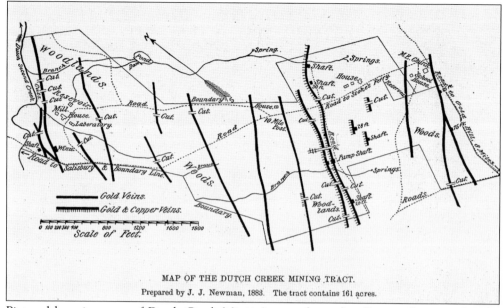

MAP OF THE DUTCH CREEK MINING TRACT.

Prepared by J. J. Newman, 1883. The tract contains 161 acres.

Pictured here is a map of Dutch Creek Mining's tract, located in Rowan County, 10 miles southeast of Salisbury. (North Carolina Geological Survey.)

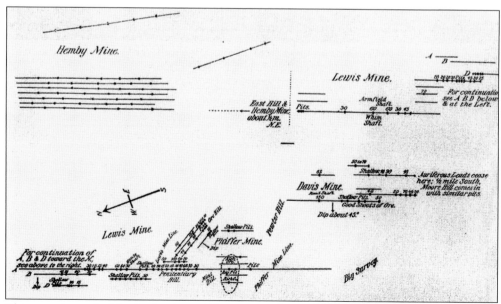

This map shows the Hemby, Lewis, and Davis mines, located in Union County, about two miles south of Indian Trail. (North Carolina Geological Survey.)

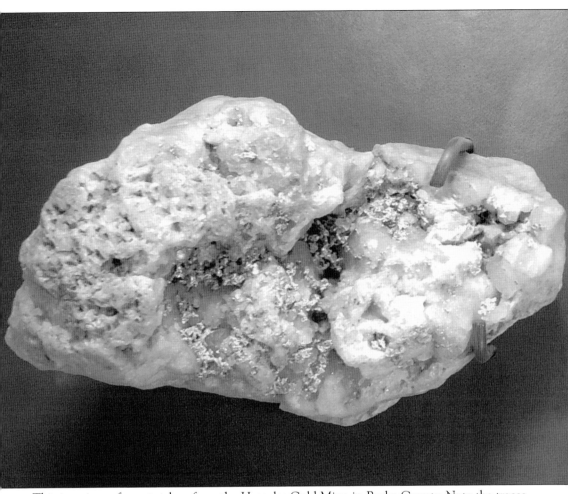

This is a piece of quartz taken from the Hercules Gold Mine in Burke County. Note the traces of gold embedded in the rock. (Schiele Museum of Natural History.)

Early Spanish expeditions led by Hernando de Soto and Juan Pardo searched the mountains of Western North Carolina unsuccessfully for gold.

Five

WESTERN NORTH CAROLINA GOLD MINES

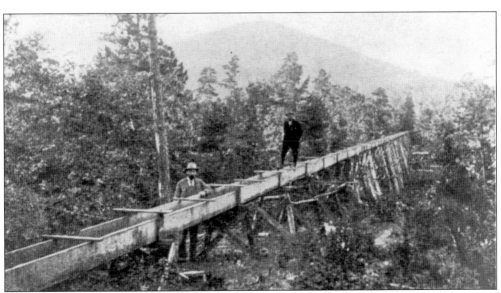

Two men view a sluice at a placer mining operation in the South Mountains of Burke County in 1896. Riffles in the bottom of the sluice collected gold as other materials washed by. (North Carolina Archives and History.)

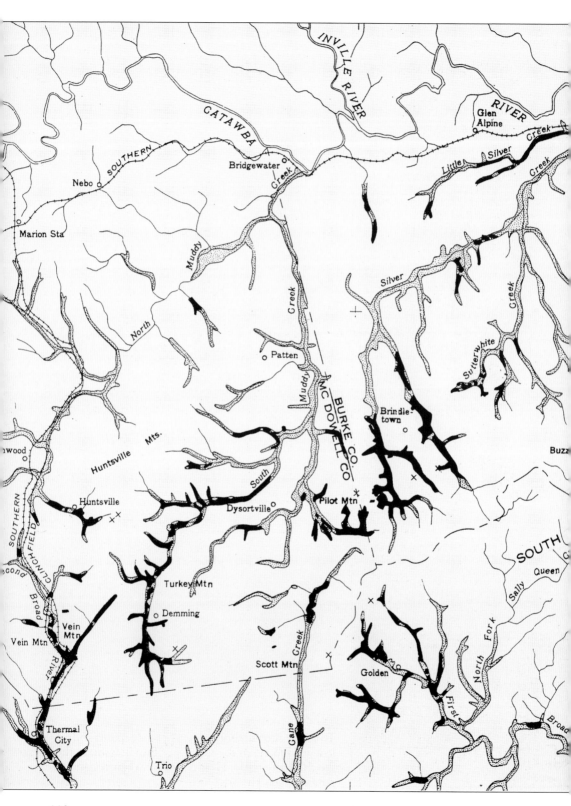

110

This map shows the location of pacer deposits and lode gold found in the vicinity of Brindletown, in the South Mountains of North Carolina. (North Carolina Archives and History.)

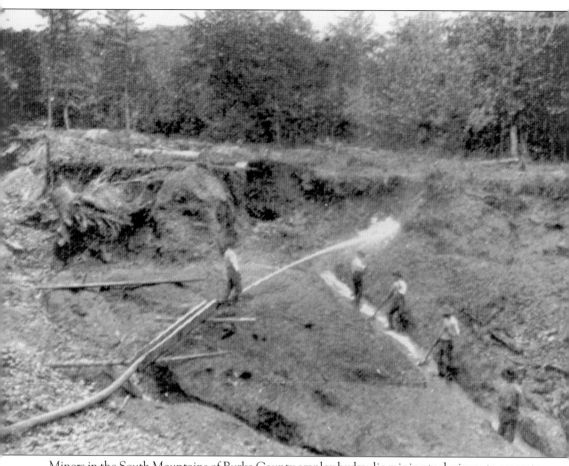

Miners in the South Mountains of Burke County employ hydraulic mining techniques to separate gold containing ore from sand and other rocks. (North Carolina Archives and History.)

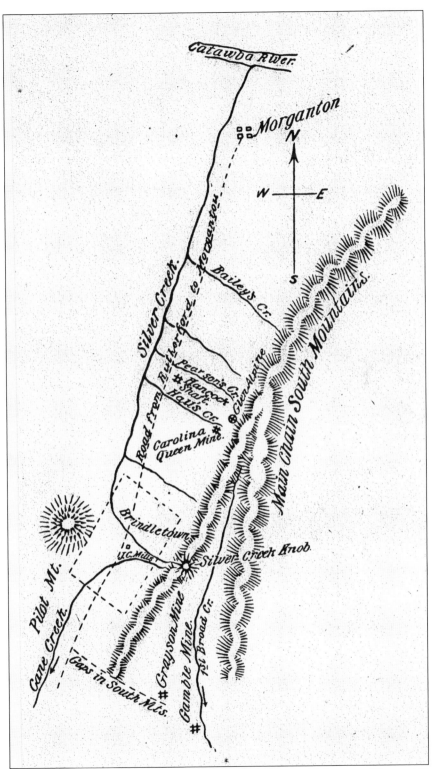

A c. 1895 map of the South Mountains depicts the locations of gold deposits. (Kerr and Hanna.)

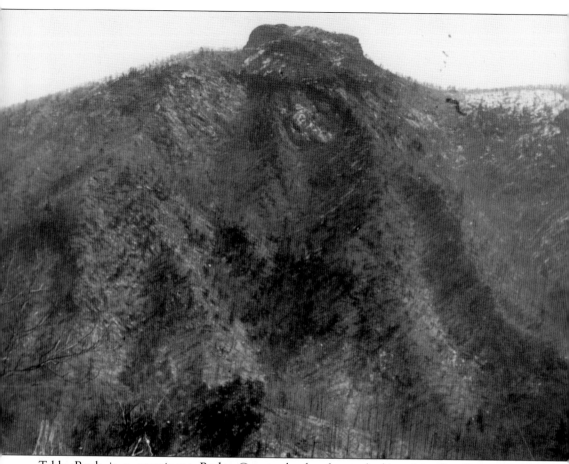

Table Rock is a prominent Burke County landmark overlooking Linville Gorge. Gold prospecting occurred on the ridges leading up to this peak, shown here in 1911. (North Carolina Archives and History.)

This photo, taken in 1902, shows some of the gold workings in a stream in a remote part of Cherokee County. (North Carolina Archives and History.)

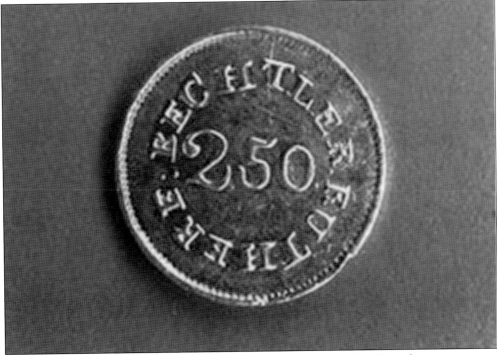

Pictured is an example of one of the coins minted by the Bechtler family at their private mint in Rutherfordton.

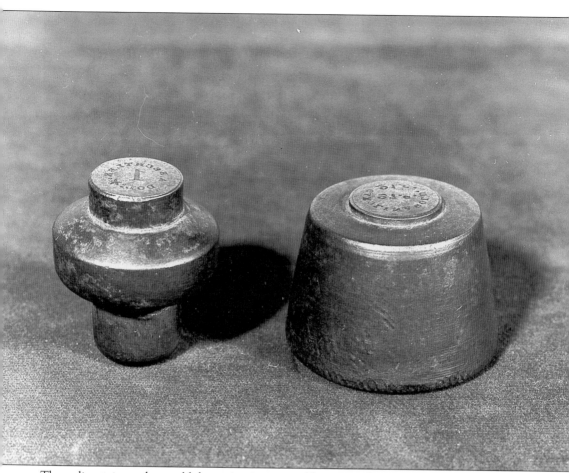

These dies were used to mold denominations on gold coins at the Bechtler Mint in Rutherford County. (North Carolina Archives and History.)

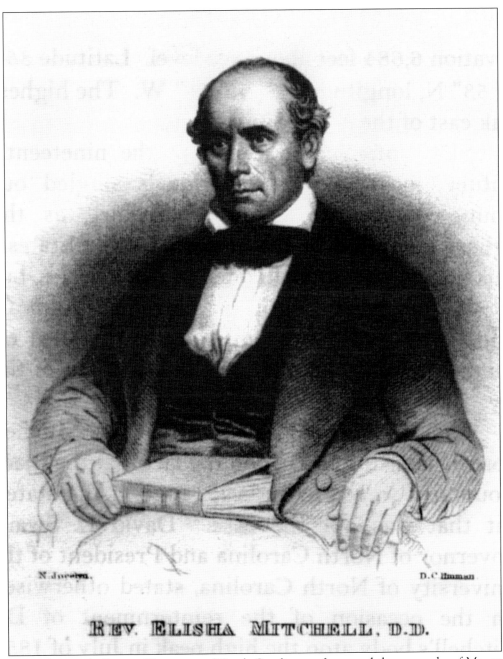

N. Jocelyn. D. C. Hinman

REV. ELISHA MITCHELL, D.D.

Dr. Elisha Mitchell was a University of North Carolina professor and the namesake of Mount Mitchell. His geologic study of North Carolina shed light on much of the gold-mining activity then in progress across the state.

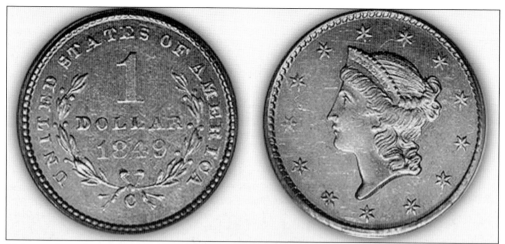

Coins such as these were made at the United States Mint in Charlotte.

Due to the enormous amounts of gold being discovered and mined in its vicinity, Charlotte was selected as the site for the first branch of the United States Mint. Over $5 million worth of gold coins were minted there from 1836 to the outbreak of the War Between the States in 1861. Gold brought in by area miners and accepted by the mint's assay office was melted, molded into coins, and stamped. The Charlotte Mint was designed by noted architect William Strickland, whose better known works are the Second Bank of the United States and the tower of Independence Hall, both in Philadelphia, and the Tennessee State Capitol. The Federal-style Charlotte Mint was originally located in downtown Charlotte. During the Civil War, it served as Confederate headquarters for the Charlotte area and later as a military hospital. After the war, it served as an assay office. The building was scheduled for demolition during the Great Depression, but a group of local citizens worked to save it from destruction. The mint was moved to its current location on Randolph Road, where it was expanded and remodeled. On October 22, 1936, it opened as North Carolina's first art museum, the Mint Museum of Art.

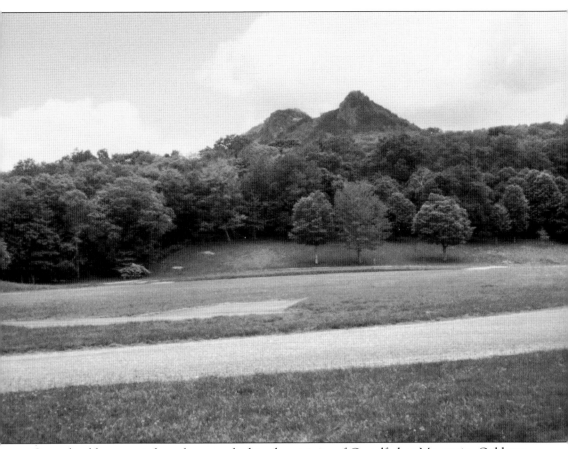

Several gold prospects have been worked in the vicinity of Grandfather Mountain. Gold was extracted from Grandfather Gold Mine from the 1870s into the early 20th century. Ore taken from here was hauled overland to other points for processing.

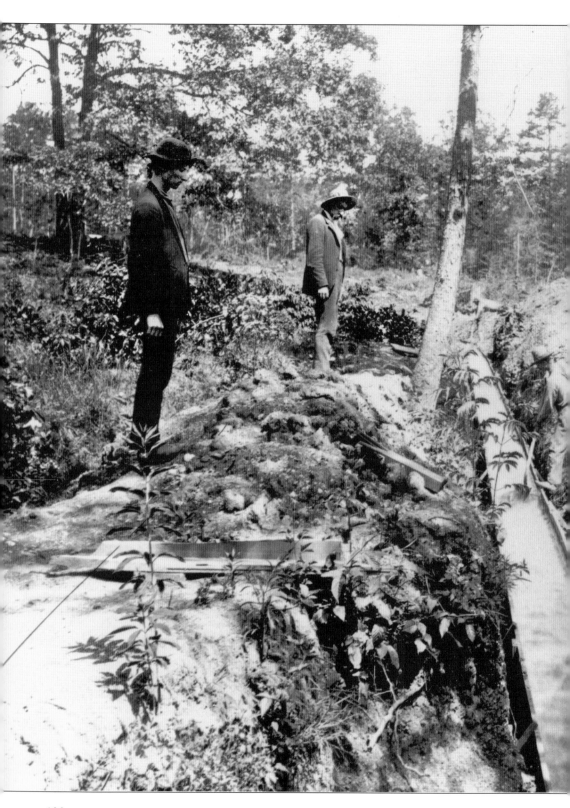

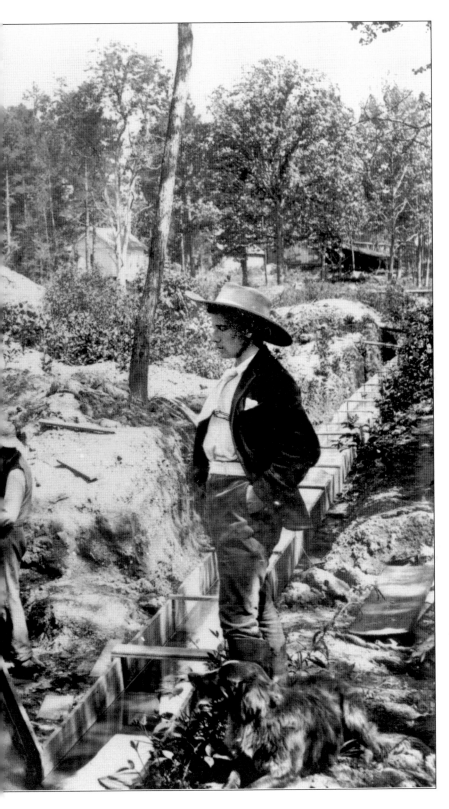

These miners
are working
the sluice
boxes at a
gold mine
in Stanly
County.
(North
Carolina
Archives
and History.)

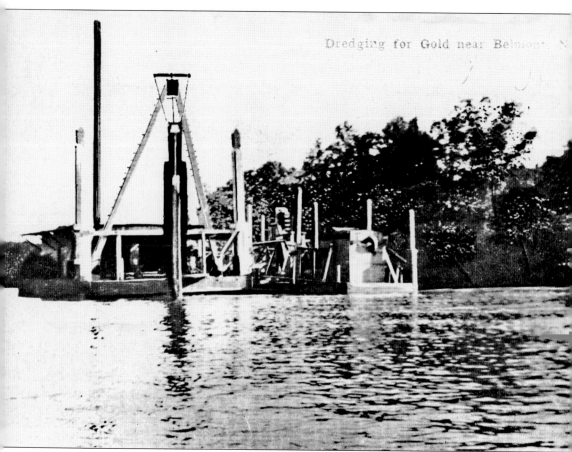

Dredges such as this one, floating on the Catawba River near Belmont, were often used by miners to extract gold from gravel in the bed of a river. (North Carolina Archives and History.)

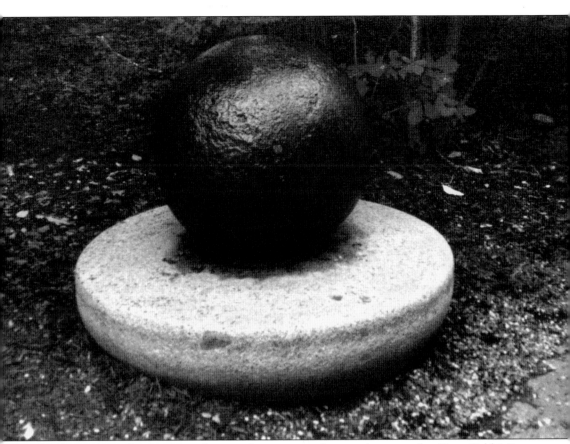

This large iron sphere is one of a pair that were used to crush ore at the Gray Gold Mine in Randolph County. These massive balls, one weighing 6,000 pounds and the other 4,000 pounds, were crafted in Belgium and shipped to Wilmington. They were then taken on a steamboat to Fayetteville. From there they were drug up the Fayetteville and Western Plank Road to Asheboro, an operation that took 16 yoke of oxen. The large iron balls eventually became the property of Joseph D. Ross Jr. and were donated to the North Carolina Zoological Park by his children.

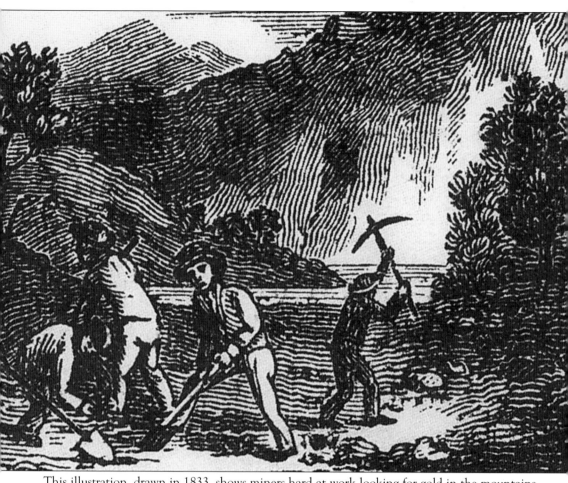

This illustration, drawn in 1833, shows miners hard at work looking for gold in the mountains of North Carolina. (North Carolina Archives and History.)

GLOSSARY

amalgamation—Process where mercury is used to extract gold from ore. In this process, ore is crushed by heavy hammers; the crushed ore is then passed over mercury-coated metal plates. The absorption of the gold by the mercury forms an amalgam, which is then heated to separate the gold from the mercury.

amalgamator—Machine used in mill sections of gold mines to separate gold from ore. Mined ore is first run through piston-like heavy hammers. The crushed ore then passed to the connected amalgamation table, which consists of an overlay of mercury-coated metal plates.

assay—Test used to determine the proportion of gold in ore. Assay offices were common at gold mines and in gold mining communities.

cyanidation—Process where ore is passed through a potassium cyanide solution to extract gold.

dredging—The use of a large machine, often mounted on a boat or barge, to excavate ore from the bottom of a body of water.

drifts—Horizontal tunnels that follow the ores in an underground mine.

fineness—Weight proportion of pure gold contained in an alloy.

fool's gold—Pyrite, a mineral with a brassy yellow color that is often mistaken for gold.

geology—The science that deals with the study of the earth, its composition, and its history.

gold rush—The sudden rush of large numbers of people to a locale where gold has been discovered. Many are lured in hopes of striking it rich.

gold weight—Gold is weighed by the troy system, the standard system of weights used for gold and other precious metals. Twelve troy ounces equals one pound.

hydraulics—Process of mining where placer deposits are sprayed by powerful jets of water that sweep away gravel to expose gold.

igneous rocks—Rocks, such as granite, that are produced by solidification from a molten state.

karat—The purity of gold, expressed in 24ths. Twenty-four–karat gold is pure gold, while 18-karat is 18/24, or 75 percent pure and 25 percent alloy.

kibble—A large bucket used to hoist ore from a mine. Workers often rode kibbles into and out of deep mines.

mercury—Also known as quicksilver, this metallic element, liquid at normal temperatures, combines with most metals to form amalgams and is used in the amalgamation process of separating gold from ore.

metamorphic rocks—Rocks formed by heat and/or pressure and changed from their original state.

mines—Large holes dug in the earth to extract precious metals, ores, or gems.

ore—Naturally occurring material from which gold is extracted.

placer mining—The natural gravity process of separating gold from weathered debris such as sand.

rocker—Device used for small-scale placer mining. Rockers were usually hand operated with the exception of large cradles, which were several rockers connected. Smaller, hand-operated rockers were operated by shoveling gravel into the rocker, pouring in water, and rocking the device to wash away the gravel while leaving the heavier gold.

sedimentary rocks—Rocks formed by the deposit of sediment by water, wind, and ice.

shaft—A steep, vertical opening dug into the ground near a body of ore.

sluice—A trough used in placer mining to separate gold from ore. As water washes away gravel in the sluice, small riffles in the bottom collect gold.

tramway—Track for carrying ore from mines.

vein—Thin, igneous rock or mineral filling in a crevice in a rock.

OTHER ARCADIA TITLES BY JOHN HAIRR

Images of America: Outer Banks
ISBN 978-0-7385-0169-7
$21.99

Images of America: Florida Lighthouses
ISBN 978-0-7385-0326-4
$21.99

Images of America: North Carolina Lighthouses and
 Lifesaving Stations
ISBN 978-0-7385-1520-5
$21.99

Making of America: Harnett County
ISBN 978-0-7385-2379-8
$24.99